MODELLED SCULPTURE
and PLASTER CASTING

MODELLED SCULPTURE

and
Plaster Casting

Arnold Auerbach

SOUTH BRUNSWICK AND NEW YORK:
A. S. Barnes and Company

© *Arnold Auerbach 1961*

Library of Congress Catalogue Card Number: 62-13152

A. S. Barnes and Co., Inc.
Cranbury, New Jersey 08512

REISSUED, 1977

ISBN 0-498-01951-9

Printed in the United States of America

To my wife, Jean, who has given so much time, energy and goodwill towards the preparation of this book.

The Author is greatly indebted to Miss K. H. Bourne for her most valuable assistance and co-operation in helping him to make the photographs which illustrate this book; he is also very much indebted to Mr. William Matthews.

He would like to thank Mr. G. H. Deeley, M.B.E., F.R.B.S., for so usefully discussing some technical points.

Contents

PREFACE and INTRODUCTION

THE Oxford Dictionary defines Sculpture as the "Art of forming representations in the round or in relief by chiselling, carving, casting or modelling". In other dictionaries may be found other definitions, for words are but symbols which convey ideas used in speech or in writing, with such precision only, as sound may convey.

In sculpture this question of definition is not without importance, for you may learn from other sculptors and also from other dictionaries, that sculpture should be defined more precisely as the art of cutting or carving alone.

It is not the purpose of the present book to deal with the theoretical background of the activity now, perhaps somewhat loosely, called Sculpture, but contemporary trends cover such an increasing field of visual forms, technical processes and new materials, that it seems important to indicate, to some extent, the limits of the territory on which this book touches and to indicate also the attitude of the author himself as a practising sculptor.

Ideas are communicable in the art of sculpture by the shape which is conveyed to the eye through the medium of the material used. The idea is inherent in the form which is given to any particular material used by the sculptor and there seems no reason in the absolute why forms cut in hard material, such as stone or wood, should be of greater value, in terms of the sculptural ideas expressed, than forms modelled in a soft and pliable material such as clay. Indeed the choice of a medium or mediums by any sort of artist will probably be decided by unconscious as well as conscious factors and the question of preference will be decided by temperament and by the necessities of any particular type of work, rather than by considerations of essential value. In sculpture, whatever material be used, the idea and the form in which it is presented will be inter-dependent and indeed indistinguishable. The difference between cutting and carving on the one hand and modelling on the other—the two prime modes of approach in using hard and soft materials (the glyptic and the plastic modes)—will certainly involve differences of techniques which will influence the development of the sculptural idea. But these differences will in no way confer greater or lesser intrinsic value of themselves. The plastic mode is described in this book and clay is the chosen medium.

The subject-matter in sculpture, as in art generally, has, until the contemporary or

near contemporary period, for the most part concerned itself, in some measure at least, with representation of the visible world. The human figure has perhaps been given the highest rank as subject-matter for sculpture because of its complex subtlety of shape and its sense of organic growth, its universal appeal to the human understanding and its immediate power of conveying emotion to the human mind by direct suggestion.

There is, theoretically at least, no reason why any shape or pattern, constructed in any material, should not stimulate the imagination visually. In the contemporary world where new techniques and new materials are being assimilated by the artist at great speed in the endeavour to originate entirely new forms, a variety of inventions, some-times ingenious in both material and technique, are being created.

With new conceptions of the nature of the universe and greater exploration of space, new modes of expression are being tried out whose relationship to what has hitherto been called sculpture is tenuous and doubtful, and a series of new objects has emerged which is at the moment classified as sculpture. It seems possible that these objects may be classified later under some other heading, for there would seem to be some point in the aesthetic arrangement of shape where, in fact, a somewhat different range or type of sensibility is called for in the observer who will have to receive the message conveyed by these forms.

It is in no sense the object of this book to examine such matters critically. Its object is purely one of helping the general student to obtain a mode of approach to the more simple technical problems involved in the making of sculpture in clay, and giving it some permanent form in plaster, well within the bounds of orthodoxy. This approach would still seem to the author to be the most fruitful basis of sculpture proper, whatever be the later adventures of the student into the making of abstract or semi-abstract object-images. These latter may well stimulate the inventive craftsman, but in the long run they may have only doubtful validity, regarded as sculpture itself.

CLAY

Clay is a soft plastic earth formed for the most part as a result of the wearing down and decomposition of rocks containing aluminous minerals, such as granite. Many other ingredients are often present—among them oxide of iron. If the clay contains iron it turns red when burned. All the brown clays have iron in them.

Firing potters' clay is the kind most generally used for modelling and may be bought at most art material shops in either powder or moist form. The moist form of clay is generally recommended for beginners, as the addition of water to the powder can be a messy and uncertain job for the inexperienced, before a proper consistency is obtained. It is usually sold in quantities of seven and fourteen pounds, or by the hundredweight.

Although it can be obtained from pottery manufacturers in a variety of colours it is most usually supplied by art stores in grey or red. Some sculptors feel that the great luminosity of grey clay makes it more difficult to see the modelling, others feel that the red clay is over-rich for the eye, with its deep shadows, and the somewhat complimentary finish which it gives even to a rough work. These things are purely a matter of personal taste; follow your preference—it will probably be in accord with your natural sense of form.

Clay must of course be kept in a constantly damp state for use and contained, therefore, in some sort of receptacle which will not rust or deteriorate with moisture. A large, strongly made wooden box, lined on the inside with zinc or lead, and with a hinged lid, tightly fitting and similarly lined, is usual for storing large quantities of clay. This is known as a clay-bin; but for general purposes and for smaller quantities of clay, a good-quality galvanized dust-bin will serve excellently—one of regulation size standing about eighteen inches high, from the base to the top of the cylindrical body, will hold ample clay for all the purposes of this book. A well damped and not too light cloth should be placed on top of the moist clay before the lid is closed down. The lid should be removed from time to time and the cloth examined to see that it is quite damp. This cloth should be absolutely clean when put in first, in order to avoid the possibility of any fungus developing.

Clay may be used almost indefinitely. It improves rather than deteriorates with use;

but after using—by which time it will probably have hardened to greater or lesser degree—it should be broken up into small pieces, about the size of a walnut, before being put back into the bin; if the clay has hardened completely, it can be broken up into pieces of suitable size with a hammer or mallet. In order to soften the clay thus returned to the bin, it will be necessary to pour water over it until the level reaches almost to the top of the clay; it should be left like this for about twenty-four hours until the clay has absorbed sufficient water. Any surplus water should then be drained off. If the bin is kept outside, in the garden for instance, a small round hole may be made in the side of the bin a few inches from the ground and a small stopper of rubber or cork should be tightly inserted. After the water has been standing long enough to soak the clay, removal of the stopper for a short time will allow any surplus water to drain away and the stopper can then be tightly inserted again.

Before using again, of course, the now properly moist clay must be reconditioned. This can best be done by knocking it together on a board or flat surface with a spade or thin iron bar or the like—that is, cutting it through and through and beating it together again alternately, until it is a pliable mass of even consistency. Kneading quickly with the hands also helps to give plasticity.

If the clay returned to the bin is bone dry, when the fresh water is added it may crumble into something like mud and be altogether too moist for use. In this case it will have to be exposed to the air until it dries to a somewhat stiffer consistency and then reconditioned as before. It must be beaten and kneaded again thoroughly, in order to let it regain its full cohesive property. Where possible, it is perhaps better to avoid letting the clay dry out entirely, thus saving much trouble.

When clay is really well conditioned it is neither so moist that it sticks all over the hands like mud, nor so stiff that it impedes absolutely free handling—indeed, well tempered clay is a most pleasurable and easy material to manipulate. The great sculptor Auguste Rodin, when asked to criticize the work of any young sculptor, was reputed always to have first demanded, "Let me see your clay!" He would then proceed to test its condition by feeling it with his own very capable hands, before proceeding to examine the work itself.

The warmth of the hand very soon dries up and stiffens small pieces of clay while working. These pieces should always be put aside and fresh material used from a larger mass of well prepared clay kept ready nearby and covered with a damp cloth to keep it moist. Some sculptors, before starting to work, prepare rolls of well-tempered clay made into a pile and kept under a damp cloth. A little experience and common sense will soon give a method of working—but it should not be necessary to have to keep going back and forth to the clay-bin as you work.

Always try to have a quantity of really ductile clay on the board or near to hand when starting to work. If an occasional piece of hard clay or a lump, made out of pellets put aside in the course of working, should need softening—make a few holes in this and fill the holes with water. If it is left thus and wrapped in a damp cloth for about an hour, a little kneading will soon restore the lump to easily workable condition. Some powdering of the clay on the hands as their warmth dries it up while working, is inevitable; a small damp sponge to rub over them is very useful here and will help to save the dried clay from constantly dropping off the hands and being trampled all over the floor.

Modelling Stand

A first consideration will be some suitable stand on which to place the modelling while at work. It is of the first importance to be able to view the work constantly from any and every angle and a turn-table is almost essential for any except the very smallest models.

A wooden stand with turn-table top as shown in the accompanying diagram (page 14) is perhaps the most serviceable type. Both three and four-legged stands may be obtained with slighly differing proportions. Some suggested measurements are marked on the diagram here which illustrates a three-legged stand. The three-legged stand takes up less floor space—the four-legged one stands more firmly and is less liable to be twisted out of shape at the top if any considerable weight of clay or plaster is being moved round on the turn-table. Very firm tripod metal stands are available at somewhat greater cost— these take up less space and are more easily transportable as they can be folded up.

If, however, it is only possible, for reasons of cost or space to make use of some existing solid table or bench, it is possible to purchase a turn-table stand of miniature height which can be placed upon it. Failing this, a turn-table, itself, may be made in a variety of ways.

In principle, a turn-table always consists basically of a solid board with a round shaft or spindle of wood (or metal) firmly attached underneath at the centre, which will rotate in or through a circular aperture made in the centre of another board placed beneath it. The smooth rotatory movement will be facilitated by any of a variety of devices, of which the simplest is, perhaps, to fix in between and on to both upper and lower boards, a disc of wood about half-an-inch thick and—say—not less than 6 inches in diameter, with a circular aperture at the centre to take the spindle-shaft. If two discs of similar size, made of tin, zinc or other metal sheeting are placed between the wooden discs (with, of course, a circular opening in each to let through the shaft) and quite free, and if the surfaces of these metal discs which touch each other are covered with powdered

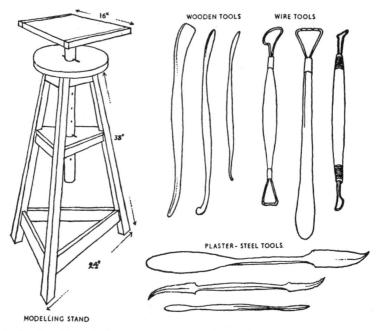

WOODEN TOOLS

WIRE TOOLS

16"

38"

22½"

PLASTER- STEEL TOOLS.

MODELLING STAND

black lead, this should make a quite practical and easily moving turn-table.

Alternatively, a circular channel made in the lower wooden disc filled with ball-bearings just reaching above the level of the disc, will allow easy movement of the upper board.

It is, of course, better to have a turn-table stand of proper height; but it is indispensable to have a turn-table of some sort at least, to enable the work to be turned round constantly.

Base-Board

The next requisite will be a board on which to work. It is intended to make use of this, also, as a base-board for a head armature. A board not less than a foot square will be a convenient size. To make this board, three lengths of wood, each piece 1 foot in length, 4 inches wide and 1 inch thick, should be placed side by side, closely touching each other. They should be nailed down firmly to two transverse batons crossing the grain of the upper lengths which will help to prevent warping. It is often recommended that three lengths of baton should be placed underneath, thus making a double, cross-grained board all over, which will be stronger and should the better prevent warping from

moisture seeping through; but in practice this double board can be very clumsy to handle and is often, in fact, more liable to warp, because any water getting through the upper layer of wood is apt to be trapped between the two sets of boards.

The measurements given for this board are average and useful, and a board of this size can later be used as a base on which to build an armature for a life-sized head; but here again, there is no rule and most sculptors accumulate a variety of base-boards of different sizes and sorts—larger ones to take and support the armatures for a heavy bust or figure, for instance. But wood that is too thin is much more liable to warp and should not be used. In all cases, a liberal coat or two of shellac varnish (white polish) will always give considerable protection and help to stop the wood absorbing moisture from any clay laid on it.

Tools

Similarly, a large number of useful tools are usually collected as work proceeds; but the necessary minimum, to begin with, should include two or three spatulas as shown in the accompanying diagram (the best wooden tools are made of boxwood), and two or three wire tools also, for cutting and clearing hollows. Suggested shapes for these are also shown in diagram. In addition, one wire tool which has thin wire wrapped spirally round a more substantial and rigid brass wire can also be very useful upon occasion; more especially when the clay has become a little hard or over smooth—this tool has 'bite'. A little practical experience will soon show how far it would be helpful to add to this collection, but it is better to start with a bare minimum. Every craftsman becomes attached to certain particular tools of his own choosing, or even of his own making.

A pair of simple calipers with a butterfly-headed bolt and screw for tightening the arms at the centre will be necessary in order to take and compare measurements. These may be obtained in either wood or aluminium; the arms should not be less than 9 inches in length.

A pair of pliers, which will cut wire and also hold it firmly when twisting and shaping it, will be required; and of course, last but not least, a good hammer.

Work-Room

A word may perhaps be said here as to the lighting of any room to be used as a studio for sculpture. If a top or high light is not available, it may be found helpful to obscure the lower half of the existing window with some sort of blind or cover. A very low lighting can be extremely disturbing to the modelling, making it difficult to 'read'—particularly so for the beginner.

MODELLING EXERCISES *chapter 2*

Place the base-board on the turn-table and put on to it a good sized lump of well kneaded clay or a pile of clay rolls—that is to say, pieces of clay flattened as pastry is flattened on a board, but much thicker and then made into rolls about 5 or 6 inches long. Keep this clay covered with a thoroughly damp cloth.

Take a piece from this store of clay and quickly knead it between thumb and first finger until you have got the feel of it and then attempt to make any odd but more or less geometrical shape, not more than a few inches in height—a sphere, a cone, a cylinder. Roll the clay on the palm of the hand or even upon the board; add pieces, cut pieces away. This should be done with absolute freedom. Above all, play should be made with the clay until real familiarity with its plastic character is felt.

If simple geometric shapes should at first seem to require too much discipline, then make small, free shapes in the way that a child plays with plasticine or modelling wax. Roll and flatten small pellets of clay until they suggest flower petals and join these up by pressure until they suggest whole flowers, or make the flattened pellets into leaves and foliage—but do not on any account try to make these flowers or leafage into an exact copy of any flowers or foliage in nature, particularly as regards thickness and scale.

Suggestions may be picked up from nature as to general character and variety of shape in order to promote inventiveness, but this exercise is really prompted, especially at this early stage, only to give freedom and fearlessness in actually handling and shaping small pieces of clay, and combining them.

This free exercise should be followed by attempting the more solid shapes of vegetables, fruit or any other objects of simple form which may attract the eye of the modeller. Such models should be made only a few inches in size and as quickly as possible. They may be rolled in the palm of the hand, pressed and shaped with the fingers or the wooden spatula, cut with the wire tool. Only the very general shape should be sought and little regard paid to surface texture or detail.

When these elementary exercises have given some familiarity with the feel of clay, first in comparatively loose flakes or flattened pellets and then in more solid form, geometric figures should be attempted with somewhat greater precision. A cylinder

may be made by rolling a small lump of clay on the board and the ends may then be cut and trimmed with the wire tool and wooden spatula. Next, a sphere, a cone and a cube can be made. Some considerable care should be exercised with the cube; the wire tool can be used to cut and the spatula to trim the edges. Where it is necessary to add a piece of clay, make a small pellet of soft clay with the thumb and first finger, shaping it and pressing it on to the main mass lightly with the wooden spatula.

If the first roughed out mass of the cube is left to harden a little in the air before proceeding, so that the clay to be used later from the store under the damp cloth is slightly more moist and plastic than the cube, then it will be good practice to build up and trim the final surface of the cube by a process of pressing and flattening small pellets of this slightly softer clay all over the five planes (or flat surfaces) of the cube visible to the eye above the board.

This simple method of building up to the final form by means of adding flattened pellets of clay of suitable size, is indeed one of the most logical and amenable techniques used in modern sculpture in clay. If the pellets are applied with sensitive precision and the forms desired are conceived clearly, the work will have a certain very attractive and also decorative aspect, as a by-product, as it were, of the clarity of the method.

At this stage—and indeed later—this technique of building up the form towards the final shape by the addition of small pellets of clay, slightly more plastic in consistency than the main mass of the sculpture being worked upon, is likely itself to develop in the sculptor the idea of formal, logical growth—of consistent development outwards from the smaller mass of the roughed out primary shape to its final form.

This idea of growth by accretion, starting directly even from the first clay put upon the armature (which will later be used as a support for larger models), is perhaps one of the most essential ideas in the building up of a piece of sculpture where the natural property of the clay is to be given its full expression.

There are, none the less, dangers when this method becomes, as indeed it can and often does, later, an end in itself and when its decorative, textural character is used to hide emptiness of form beneath surface neatness and dexterity of craftsmanship.

Having shaped the cube successfully, various other geometrical figures should be made and if possible combined into freely invented formal arrangements—combinations of rectilinear solids, ovoid shapes and so on. It should be observed here that formal construction in sculpture, no matter how much disguised, or perhaps it should rather be said veiled, by surface movement, depends upon the underlying simplicity of geometric solids to give it impressiveness of mass and potential sculptural force.

Considerable time should be spent in designing and building such geometric figures on a small scale, not only in order to accustom the hand to build solid shapes in clay,

but also because it will help to give the student a feeling of the potential power inherent in the basic architectonic solids which underlie the forms of nearly all the traditional monumental schools of sculpture.

Take next, one of the small cylinders and taper it slightly and regularly, by rolling it with greater pressure towards one of its ends, on the board or palm of the hand, so that it would become, if this procedure were to be continued, the lower end of an extremely tall cone. Make a downward cut at a slight incline through the upper and smaller end of this tapering cylinder and trim and slightly hollow this inclined top surface with a rounded wire tool. Next make an ovoid or egg shape just a little larger in bulk than this cylindrical shape. In making this, not so simply made, solid shape, use the palms of the hand and the fingers, exerting a little pressure here and there; roll it on the board, use the wooden spatula to add small pellets of clay and flatten them out into the surface of the ovoid—the method is not so important as to attain the shape.

Place this clay ovoid upright on to the top surface of the cylindrical shape—the whole figure should stand not much more than 4 inches high. Attach it to the cylinder by pressing the lower end of the ovoid on to the top of the cylindrical shape, or press the upper end of the cylindrical shape at the top of this incline on to the ovoid at the back, with the edge of the spatula; or press small pellets of clay around the join with the spatula—or use a mixture of all three methods. Then add a little fullness of clay to the back of the ovoid and the little model should convey clearly the very basic form of a head when set upon the neck (see illus. 4).

The suggestive shape of this simple head form may be increased by making slight depressions where the eye sockets would come and by adding a small strip of clay in the middle where the nose would appear, attaching it and smoothing it into the ovoid at the sides and bottom either with finger or spatula, working the top edge gradually and evenly into the upper surface of the ovoid. Two larger pellets may be attached at the sides and shaped with the utmost simplicity to suggest the flat pattern of the ears.

After doing this exercise two or three times—for it will probably be found that at the first attempt considerable distortion of the soft clay will be made, particularly in the cylindrical quality of the neck, if only from handling—let one of these models harden for an hour or two, and then attempt to develop this basic head form into something a little more suggestive of a real head. Turn the little model round so that it can be seen from all angles as it is developed.

It would be useful, at this stage, to look with attention at some actual living head, not in order to attempt to make a realistic portrait, but in order to note the way the forehead projects over the cheeks and the general mass of the nose projects above the upper lip; the way the frontal plane of the nose ascends into the forehead, and the side planes of

the nose recede and melt into the cheeks; observe too the way the mass containing the mouth projects over, and declines to the chin.

The whole model need not exceed about 4 inches in height. Add clay in small pellets and flatten or press these pellets lightly into the main mass with spatula or finger; cut depressions with the wire tools or press them out with finger tips and spatula. Work as deliberately and lightly as possible, using extremely simple forms which do not destroy the unity of the first ovoid shape, but only develop slight suggestions of the various features emerging from it — change of proportion alone will give surprisingly different quality of plastic expression. See where the shaping instinct leads to on this small scale, when the main shape is already determined by the basic form first established.

Drawing

Meanwhile this activity should always be accompanied by the practice of free drawing, with the particular object of exploring and expressing the actual shape of visible things in terms of line and tone. Swiftly executed and very free notation of plants, objects, heads, figures etc. should be made, at first in line only, with pencil, chalk or pen. Wherever possible, each subject should be observed and drawn from many points of view. As each new profile or changed viewpoint is registered, it should help the student to understand and grasp the nature and reality of the subject as it exists in the round. Whatever studies be made for aesthetic purposes purely, the drawing practise specifically recommended here, to accompany and reinforce sculptural activity, should be in the nature of an additional and swifter exercise in the perfectly natural, but more conventional art of drawing upon a flat surface. If a series of free line drawings of any solid object are made swiftly and rhythmically from a series of positions around it, these drawings should greatly help the intelligent student to a perceptive knowledge of the whole figure in the round.

Such drawings, made with speed, keen attention to the subject matter and rhythmical freedom will, as a by-product, exteriorize the feeling of the draughtsman towards his subject in each and every notation. In examining the drawings later, with a more cool and critical eye, the student will be able to assess more clearly emphases of proportion, rhythm and character; accents probably unrealized by him consciously before he began to draw.

Drawing will thus serve a series of different but associated purposes in the development of the student's sense of form. He will gain actual information about the all-over physical shape of his subject; he will also gain some knowledge of his own subjective reactions and bias towards various aspects of shape. Moreover, consideration of drawings will help him to choose those views of his subject which seem most suitable for sculptural expression.

Later on, in addition to these line drawings, further drawings, reinforced by the use of tone should be made. That is to say, changes of plane should be indicated with tone used freely but having some regard for light and shade. This will also help to give familiarity with the subject from the point of view of projection and recession of form within the outlines. Drawing, as such, does not come within the province of this book, but the subject is mentioned here because it is the almost indispensable accompaniment to the making of sculpture and should be pursued simultaneously with it. The drawings of the master-sculptors from the Renaissance to the present day should be examined, and in nearly all cases it will be found that whatever other qualities they may possess, these drawings have been made primarily as adventurous descriptions and expressions of shape in the solid. Nearly always they have a strongly marked rhythmical stress in definition, as a result of the endeavour to present form as a living and creative thing.

ARMATURES *chapter 3*

In making the small models indicated in the last chapter, it will probably have been noted that even on this miniature scale certain characteristics of the clay itself become very evident. First it will be observed that it is a surprisingly heavy and dense material and then that it is difficult to mould any one part of this mobile yet tenacious material without somewhat distorting other parts of the model by pressure. For this reason it was suggested earlier that the little ovoid head and the cube should be allowed to harden somewhat in the air before working more exactly on them in order to give them more complete shape.

When masses of clay of larger dimensions are to be modelled, these difficulties, of course, become very greatly intensified, and indeed, few sculptors would work upon any scale above a few inches without making a firm inner support for the clay out of more rigid materials. Such a support is called an "armature".

Armatures can be made out of any materials which will not be rotted or rusted, or otherwise adversely affected by damp from the clay, and which will be of sufficient strength and rigidity to support its considerable weight. It is as well, however, not to use armatures of such rigidity that they may not be modified or altered in the course of work (anyway, that is, unless the final shape and dimensions of the intended sculpture are actually known—as for instance, in enlarging or reducing a model to scale exactly). As the work progresses, it is surprising how often the armature can manage to appear in the most unexpected places while making any modification in the shape of the sculpture as originally planned. Indeed, it is seldom that a piece of sculpture in clay, of any complexity, can be carried through to completion without some such modification being called for, as it materializes from its first conception in the mind of the sculptor.

There is, therefore, something to be said for always allowing a certain amount of flexibility in the construction of an armature in order to permit some change in the shape of the model later, always provided that in all circumstances the structure will, at any stage, support the weight of clay to be built on it. In addition it should be remembered that it will also have to support, later, a considerable weight of wet plaster while the moulds are being made on it to take a cast in plaster.

Two of the usual and most serviceable armatures for their purpose are given here, but there is no reason why experiment should not be made with any materials, whatsoever, which fulfil the given requirements for any particular model. In fact the most varied materials possible to convenience and accessibility have been used on occasion, and comparatively large sculptures can sometimes be made quite successfully without any armature at all, if the design is compact enough and provided the base-board can, if necessary, be tilted to balance the mass of clay and to control the centre of gravity. None the less, it is highly advisable for the beginner to become thoroughly familiar with the general principle of making armatures. Nothing can be more disappointing than the collapse or movement of the clay after considerable work has been put into the modelling.

In making a life-sized head (where the weight of clay to be supported may be about half-a-hundredweight) the armature should consist of two loops of composition piping, $\frac{1}{2}$ inch diameter (lead piping is usually very heavy and over-rigid, and also very costly), each loop measuring about 2 feet to 2ft. 6 inches in length. These loops should be placed across each other at the top, and the lower, cut ends nailed to the opposite sides of a wooden upright. This upright should be about 10 inches to 12 inches in height and 2 inches square in thickness; it must be fixed down on end to the centre of the base-board. The whole armature arrangement is clearly shown in the accompanying illustration. (Illus. 5.)

The fixing of the wooden upright to the base-board may be done in a variety of ways. The simplest method is, perhaps, the one illustrated here; a stong metal angle, $2\frac{1}{2}$ inches by $2\frac{1}{2}$ inches, has been tightly screwed into each of the four sides of the upright at the bottom and also down to the base-board—this will hold the upright with absolute firmness.

Another simple method of fixing the upright to the board is to surround it, where it attaches to the base, with a socket made of four pieces of wood, $1\frac{1}{2}$ inches by $1\frac{1}{2}$ inches in section, nailing or screwing these pieces very firmly both to the upright and to the base-board—a large screw from underneath the base-board up into the centre of the upright to hold it in position, before the surrounding pieces of wood are attached, will make doubly sure that it will stand very firmly.

By whatever method this upright is fixed to the board it must be made absolutely firm, as it has to take the whole weight of the clay model above and it should on no account, whatever, be liable to sway or loosen as the work proceeds.

The two loops of piping should be nailed to the top of the upright, first flattening the ends of the piping to take the nails. Use zinc or copper, clout-headed nails as these will not rust when covered with the wet clay. The two loops of piping should be

22

bound together, where they cross each other at the top, with some galvanized or copper wire (see illus. 5), using the pliers to cut the wire and also to twist it firmly together.

In addition, one or two butterflies—that is, crosses made of two small pieces of wood tied together with wire, and hung by wire more-or-less horizontally from the top of the loops of piping—will help to support the mass of clay from sinking or slipping down the piping. These butterflies may be used also, wherever the clay projects far from the main armature; a small butterfly hung from the top of the loops, for instance, may be used to support the clay forming the chin, when this juts out considerably from the column of the neck; it will of course need a longer wire than those shown supporting the butter-flies in the armature illustrated here. This armature was made to take the upright and very compact head shown later in this book.

An advantage of these "butterflies" is that they can be pushed in or pulled out easily as required, in the course of building up the clay, and yet they will give very strong support.

All the measurements given for the loops of piping, etc., are average measurements, but as in all things technical mentioned here, to understand the general principle involved is the important thing.

Thus, if a head with a particularly long neck is being made, it may well be preferable to use a greater length of piping so that the base of the neck, which itself may form a slender column thrusting upwards and outwards from this point at a forward angle, will only barely touch the top of the wooden upright. This upright can form a very rigid mass which will get in the way of the easy modelling of the junction of the neck and chest. By using a greater length of piping this piece of rigid wood may be avoided altogether and the junction of the neck and chest may be modelled higher up the arma-ture supported only by the lead piping; the chest plane will then cover and avoid the obstruction of the top of the wooden upright altogether. In this way, also, you will have a more flexible armature; for the piping may be bent, or, if it should protrude where it is not wanted during the work, it may even be lightly hammered back inside the clay model.

Ideal armatures, of whatever material, should always run near the centre of the mass being modelled—in actual practice they can, as has been mentioned earlier, appear most awkwardly in very unlikely places, if any change of design or modelling should be necessitated during the work. Allowance for this should always be made as far as possible when constructing armatures, so that freedom of expression, particularly in the early stages of setting up the model, is not impeded.

One further suggestion may be made: when using piping or any other smooth material in an armature, the clay may be inclined to slip over it and fail to grip. This

failing may be corrected by twisting some non-rusting wire, spirally, down its length which will act as a break and prevent the clay from slipping. If necessary, even, some small flat pieces of wooden lath may be inserted into the wire spiral, here and there, and these will form an excellent additional brake and support.

With an armature for a head only, and especially where the head is of simple design such as the one to be illustrated here, this should, of course, be quite unnecessary; but with any elongated form such as the extended limb in a figure, particularly on a large scale, this will be found to give considerable support without impeding the flexibility of the armature.

Keeping the Model in Condition

It will of course be necessary to keep the clay model in suitable condition for continuous working, sometimes over a period of many months, as soon as any serious sculpture is attempted. In the early stages it will be sufficient to place damp cloths over the whole surface of the model. These cloths should, of course, be soft and not of a thick or strongly textured character, which would be liable to upset the actual surface of the model. They should be laid directly upon the clay as lightly as possible and not dragged over it in any way. They should be thoroughly damped and wrung out, and applied freshly about once every twenty-four hours. While working upon the model without the cloths, the clay should be kept in good condition either by spraying it all over, every now and again, with a blow-spray or a hand-spray, or by sprinkling it vigorously with water from a wet sponge.

As the forms become more complete it will be necessary to keep the model damp, when not being worked upon, with the minimum of interference to the surface. Obviously the cloths must be kept, as far as possible, from direct contact with it.

One method of doing this very completely is to make an air-tight case which should enclose the clay model without touching it. This can be done by constructing a rectangular box-like framework out of $\frac{1}{4}$ or $\frac{1}{2}$ inch square wood, and then covering it on the top and sides with waterproof plastic material. But one of these sides should consist of a loose flap which will pull up to the top, and the bottom bar of the wooden framework should be omitted on this side. This will enable the whole case to be drawn over the model—after which, the waterproof flap can be pulled down and fixed with drawing-pins to the wooden framework uprights at the sides.

The loose flap should be opened up periodically and the clay within sprayed with water. In so far as this plastic covered cage remains air-tight, the model within should retain its dampness for an almost indefinite period.

Alternatively and more simply, any method of preventing the damp cloths touching

large areas of the actual surface of the more carefully modelled parts, may be used. Lengths of thin, rustless wire may be bent into flattened hoops of different sizes and the two ends inserted into the clay until some sort of a cage is left projecting from the model and thus fixed around it. Before covering a head, for instance, a hoop of wire may be placed vertically in front of the centre of the face, one point being fixed into the top of the head or the centre of the forehead and one into the middle of the chin. Another loop of wire can be placed across and in front of the forehead, the point being stuck into the clay both sides of the head. A little thought will show how many such guards are needed and where they should be placed, so that the damp cloths to cover the head are kept away from contact with the surface at all crucial places.

Yet another method of protection, which may be used alone, or in conjunction with the wire guards, is to insert pointed matchsticks or other fine lengths of wood at any points where it is desirable to prevent the cloth from touching the clay. It will be necessary to spend a few moments in filling the tiny holes made by the points of either of these guards, each time the damp cloths are removed, before working on the clay model again.

If the work is to be left for any considerable length of time without possibility of the cloths being re-damped, a sheet of thin plastic material wrapped lightly round the outside of the damp cloths, and tied closely at the base with string to exclude the air, will keep the model in perfect condition for some weeks if necessary. If left thus for too long a period, however, the wooden upright is liable to develop fungus, especially if the wood is not properly seasoned, and it is always advisable, if at all possible, to open up the model to the air periodically, and to damp and replace the cloths.

Of course, where plastic or other waterproof material is not available, the thin wooden framework case described earlier may be hung with damp cloths only. But these will have to be re-damped and re-hung constantly—the object always being, to exclude the dry air so that evaporization of moisture in the clay is avoided.

MODELLING THE HEAD (1) *chapter 4*

The making of a life-sized head somewhat stylized in character and oriental in type, has been chosen for demonstration here, because of its generally simplified character and the clear development of its design from the simple ovoid shape, balanced on a basically cylindrical neck.

The main views of this head are given, front, three-quarters and profile. Study of these views, with the accompanying photographs of the clay model in different stages of development, should enable the student to make a reasonable attempt to solve most of the technical problems with which he will be faced in making any sculptured head in the round. (Illus. 1, 2, 3.)

If he is working from a living model, the mode of approach used here can be exactly the same, except for the fact that he will then have opportunity to observe the head of the sitter from an infinite number of viewpoints and the natural forms contained in it will be of far greater subtlety and more difficult to grasp; the difficulty of co-ordinating both the subtle graduations of natural form and the complex changes of aspect, from viewpoint to viewpoint, may be found more difficult to resolve into one clear and expressive sculptural statement.

The sitter should be placed, if possible, so that the head is on a level with the clay model; it is, of course, much more easy for the sculptor to compare them both from different viewpoints when placed thus. This will probably necessitate raising the chair upon which the sitter is placed by putting it on a throne or dais, preferably one with a turn-table top or on freely moving castors, so that the sitter can be moved around easily with the head in the same relative position as the modelled head, whenever this is turned about while working. Failing a throne, a high chair with a back can sometimes be obtained, but this will have to be moved round often, as it frequently becomes necessary to see and compare both the sculptured head and the sitter from many different points of view.

Begin, then, by covering the armature with large pieces of well-kneaded clay, filling the space between the loops of piping very solidly, and making use also of the butterflies to hold up the main mass in the centre; cover and fill in, also, the lower part of

the piping right down to and over the top of the wooden upright, giving to all this lower part, the cylindrical column-like shape of the neck. Press, mould and pummel the clay very firmly together, until it is one solid mass, so that there are no air spaces inside the armature—it is well to use fairly stiff clay for this operation so that it will not sink or settle down within the armature, later.

With the simple ovoid and cylindrical form of the small model which we first made, in mind, proceed to make just such a simplified form of the head and neck upon and around the armature (see illus. 6). This shape will be used as a basis from which to build the complete head—of course, this basic form will cover the armature completely, and care should always be taken to leave the armature well in the centre of this mass; but at this stage the clay shape will be very considerably less in size, in all dimensions, than the final head which is to be modelled on it.

It would be well, even at this early stage, to have a good look at the subject, particularly in direct profile, and take note of the general pattern which this makes, especially with regard to the degree of projection which one part makes with another.

It should perhaps be observed here, that although it will be necessary in the finished work to co-ordinate a number, or series (even if not, as observed earlier, an infinite number) of aspects of the sitter's head as seen from different viewpoints into one clear statement, none the less, such is the selective power of the mind, that it will usually be found, that in the final work certain main aspects of the model will most likely impress themselves more forcibly than others upon the imagination and memory. The front view, the side profiles, the three-quarter views both sides, and the back view will probably take prime place among these.

In making the sculpture of the head illustrated here, it seemed to be a good plan to establish and differentiate these views in space, with some degree of definition, as early as possible.

With this object in view, the centre of the face was first indicated by cutting a line in the soft clay right down the front of the clay model (see illus. 6) with the edge of a wooden tool. Following this, a transverse line was cut across it, approximately at a level where the eyebrows would be placed. Where these lines cross one another, a used match-stick was inserted into the clay (any similar fragment of wood will do) to act as a marker. This should not be pressed right home but left projecting a quarter of an inch or more from the clay. The end facet of this projecting match-stick could be used as a point from which to obtain, at once, some further approximate measurements of the head to be modelled.

Using the end of the match-stick in the centre of the forehead between the eyebrows as a fixed point, measurements were now taken with the calipers from this point down

to the base of the nose, also to the centre of the mouth and to the point where the plane beneath the mouth meets the projection of the chin; these measurements were marked on the vertical centre line by making transverse cuts across it with the sharp edge of the tool.

By so doing, the main vertical proportions of the features were approximately registered on the basic shape, using the line running down through the centre of the forehead, nose, mouth and chin as a line of heights.

Then a match was stuck into the clay (if so desired this could be pointed at one end to move more easily into the mass of clay), so that its outward end would indicate the outermost point of the tip of the nose. To find this position, the main profile view of the head was carefully observed in order to try to assess the angle which the profile of the nose made down to this point from the marking point between the eyebrows on the vertical centre line. This second match was left projecting to register this position (see profile illus. 12).

Next, a very careful measurement was taken with the calipers from the match-stick between the eyebrows to the centre point of the chin (lower jaw bone) at the very bottom, and once again an endeavour was made to assess, from the profile view, the position of this point in projection. Once found this point was marked by a match-stick.

Examination of the illustration, showing the front and side views of the basic shape at this stage, should make quite clear this method of the preliminary finding of points of projection in space, before the actual modelling is made. From the foremost points at the front of the head, marked by the ends of the projecting match-sticks, some measurements should also be taken of the distances to points at the back of the head on the same horizontal levels. These levels can most easily be arrived at by marking horizontal lines round the basic head-form from the insertions of the front match-sticks.

From the front view, likewise, major measurements of width, between outermost points of the cheek bones, from side to side of the skull and jaw bone, and from ear tip to ear tip, may be marked by the insertion of match-sticks. Arcs made by the calipers from the fixed point between the eyebrows, cutting the horizontal lines drawn round the clay head at suitable points, will give the approximate positions for the match-sticks marking these points. A match-stick may also be inserted at the top of the ovoid to indicate very roughly the highest point in the curvature of the head—this match-stick also to be placed on the centre line. (Illus. 6, 12.)

To obtain accurately positioned points in depth, and therefore in true relation to each other, would necessitate working from fixed points outside the model. The word "approximate" has therefore been used here, although in fact most of the measurements obtained (as for instance from the end of the match-stick at the point of the chin to the measuring point between the eyebrows, and from thence to the back of the head, and

so on), may be perfectly accurate as self-contained measurements. The purpose of taking these measurements is advocated as a check upon free observation, especially where the eye is not fully trained, rather than as a mode of mechanical reproduction. None the less if any doubt as to the proportion or measure occurs as the work progresses, it is well to check up from as many of these ascertained points, one to the other each time, as possible; each further measure will help to check up their relative positions with greater accuracy.

The word "approximate" has been used with reference to these points registered in space by the outer end of the match-sticks, because the finding of such points in space before modelling (so long as they bear an approximate all-over correctness in relation to the central primary clay form), should give some considerable guidance as to the proportion and spacing of the final sculpture almost from the start. It should suggest a methodical way of *thinking* of the shape to which the finished work will expand as a whole, and the space which it will take up out of that surrounding the elementary clay-form first laid over the armature.

It should also prevent the error so often made by beginners, of modelling the form from one point of view only, for too long a period, so that when the clay head is turned round into a new position, it will be seen that the whole modelling has been brought too far forward upon the armature, in relationship to the sculpture. There is then no help for it but to cut back much of what has been already modelled, if the armature is to be accommodated at all within the true proportions of the sculpture. That is to say, negatively, the limits will be set by the match-sticks as regards the main projections of the final forms from a central core, from the moment the matches are inserted.

It is very possible, of course (as is indeed done in enlarging to scale exactly, from a small model, or in "pointing" a stone figure from a plaster model), to obtain a high degree of accuracy in copying an exact shape in the round, by finding points in depth over every square inch or even less, of the whole surface; but this method is not only outside the scope of this book entirely, but also outside the intention of the present procedure. The method is given here rather as an aid to the beginner in finding a few very salient proportions and positions, so that the anxiety of working altogether blind-folded as to proportion and spacing is avoided; and so that the relationship of the growing mass of the sculpture to the comparatively rigid central armature is preserved.

There are many methods of approach in these matters and temperament should always be allowed for. If the student feels sufficiently confident to dispense with all these points fixed in advance by the match-sticks, then by all means let him proceed without them. For some, a method of this sort is an aid, while to others, it can be a limitation of freedom. But the method itself is well worth consideration as giving the idea of regulated growth into space from a central core. This is important.

In any event, the student would be wise to mark some of the proportions in height on the centre line at first, and to check up some of the main measurements with the calipers, both as regards height and width, as the work progresses. It is very easy to lose the relationship of one part of the modelling to another, while one view is worked upon and observed over too long a period of time. The projection of that one part can easily be so advanced, that its relationship to the main shape is overlooked or lost. It would be wise also, to preserve, at least, the measuring point marked with a match-stick where the eyebrow line crosses the vertical centre line; and also such major marking points as the match-stick at the bottom of the chin and that at the back of the head (marking the distance from the point between the eyebrows to the back of the skull). These few points, and particularly the first can, then, always be returned to later for reference.

Perhaps the simplest way to proceed from here is to look with attention at the main profile and actually build this pattern in clay on to the basic ovoid over the centre line (see illus. 13). Use large pellets or strips of clay and build up this profile quickly and almost, but not quite, out as far as the projecting match-sticks, working the profile line right over the head in this way.

Now turn the clay head so that the front view is directly facing. Look with attention once again at the pattern which this makes against the background. Then roughly build this front elevation pattern in clay up and over the head, somewhat in the way that the main profile was established from the side view.

Here however, certain difficulties will probably be encountered and "somewhat" is perhaps, therefore, the operative word in the last paragraph.

It would be logical and consistent, no doubt, to build the silhouette pattern which the front of the head makes against the background upon the original basic ovoid shape— to show, that is, the pattern which that section of the head makes, where the form projects most fully when looked at from the front view.

A more tentative approach is suggested here, for practical reasons. It is, in fact, extremely difficult, particularly for a beginner, to grasp the idea of a solid form with sufficient clarity to be able to draw a section of it, especially when this section lies at a point in the form distant from the onlooker.

The main (side view) profile which was first established does, on the contrary, impress itself with great ease upon the eye and the mind of the onlooker.

None the less, it will be helpful if this section of the head at its widest, as seen from the front, can be suggested at least, by actually building it up tentatively in clay, at this stage, upon the basic ovoid shape.

Begin, then, by placing some clay each side, where the match-sticks were inserted to mark the top outermost points of the ears. Build out almost to the projecting ends of

each match-stick. Then continue by placing some clay pellets or strips, here and there, on a line downwards to the base and up right over the top of the head from one ear to the other, with sufficient continuity and shape only, to suggest the outline pattern which the projections of the volume make against the background. This should properly be called the section of the form as it cuts through the top outermost point of both ears. (Illus. 7.)

This section (or the pattern made by the projections of the volume as seen from the front view), in conjunction with the main profile view established earlier from the side, should act as a key, both from the side view and the front view, in establishing the shape which the whole mass of the head makes in space and also marking its outside limits therein; anyway, as regards these two main views.

Once again, as was written earlier with reference to the method of the projecting match-sticks, of which this procedure may be considered a more continuous development in clay, the idea should help to give the student an imaginative realization of the shape which a solid occupies in space, with detachment from the details of the smaller forms which help to comprise the shape of the whole mass.

Some of the extremely penetrating words of the sculptor Auguste Rodin can be most aptly quoted here to illumine this process of thought, "A head may appear ovoid or like a sphere in its variations. If we slowly encircle this sphere, we shall see its successive profiles. As it presents itself, each profile differs from the one preceding. It is this succession of profiles that must be reproduced, and that is the means of establishing the true volume of a head.

"Each profile is actually the outer evidence of the interior mass; each is the perceptible surface of a deep section, like slices of a melon, so that if one is faithful to the accuracy of these profiles, the reality of the model, instead of being a superficial reproduction, seems to emanate from within. The solidity of the whole, the accuracy of the plan, and the veritable life . . . proceed therefrom."

Now, work for a short time from the front view. Build up the forehead, spreading out the whole plane both sides of the ridge of clay marking the profile. That is, model outwards from the centre, bringing the forehead as far forward here, as the profile ridge projects. Watch the width of this forehead plane, which will extend, approximately, as far as the ends of the match-sticks placed on the eyebrow line, both sides of the measuring point between the eyebrows; beyond these limits it will incline more sharply on both sides as it turns towards the back of the head. It must not be made too square in section where the plane changes direction here, however, particularly on a realistic portrait head. This front plane of the forehead should always be studied with particular reference to its horizontal section. (Illus. 8, 19.)

Having established the plane of the forehead, work very freely all over the head,

turning it round every few minutes to note how the shape is developing from different viewpoints.

The receding plane beneath the forehead, now brought forward almost to its maximum at eyebrow level, will, of course, form the projections over the eyes, both sides of the nose.

So far the nose will only be indicated by the thin wall of clay which forms the main profile as seen from the side views. From the centre of this clay wall—but working from the front and three-quarter views, and modelling back to the cheeks, now build up the side planes of the nose. Do this roughly and simply but taking note of the width between them, particularly from side to side of the nostrils and keeping always a fraction within this width.

If the recessions beneath the eyebrows both sides of the nose seem insufficient, do not hesitate to cut these back further into the plane of the cheeks with the wire tool, making hollows to take the eyeballs. At the lower edge of these hollows, if necessary, cut the clay back so that it makes a gentle incline into the cheeks, perhaps somewhat flattening the cheek planes as formed by the original basic clay ovoid each side of the bridge of the nose, in so doing.

Use the wire tool, or any other, to cut or hollow the form where necessary at this stage; for while it is possible to make the original ovoid covering the armature so small in volume, that it will be contained, absolutely, within the smallest dimensions of the head at any point of its surface (so that every further development may be made purely by a process of building out from it), in practice, it is perhaps more useful, at this early stage, for the sculptor to feel absolutely free to establish the underlying changes of plane and shape which make up the volume of the head, with the maximum of directness and breadth while the vision is fresh. But the original simplified ovoid should still govern the general plan and construction of the head and it should not be necessary to depart too far from it in making these variations.

Study the head from every angle, moving it round constantly, but develop the forms only in a very general way, adding the clay in pellets and using the wooden spatula for the most part to place them in position; do not hesitate to hollow or cut with the wire tool where the character of the forms may require it. Build the outermost points of the projections with loose pellets as the different contours or profiles of the head present themselves.

As soon as the hollows below the forehead on both sides of the nose are cut back to the maximum depth and related to the underlying plane of the cheeks the eye sockets may be indicated tentatively.

The front view (see illus. 8) should be studied here. In this, one side of the head has

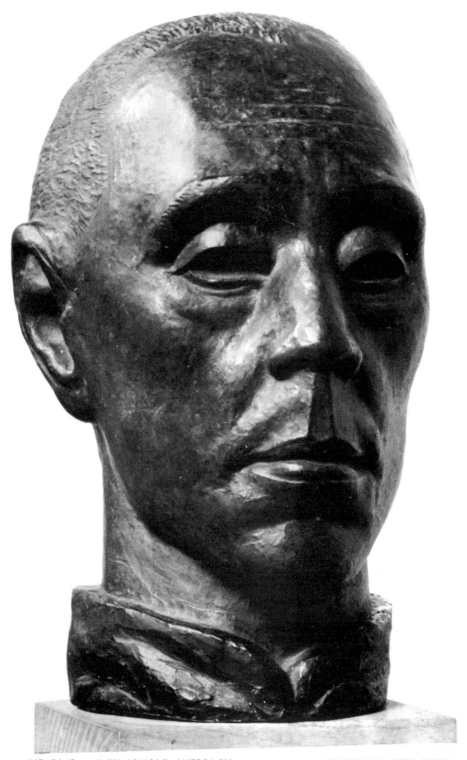

'HEAD' (*Bronze*) BY ARNOLD AUERBACH. I. THREE-QUARTER VIEW

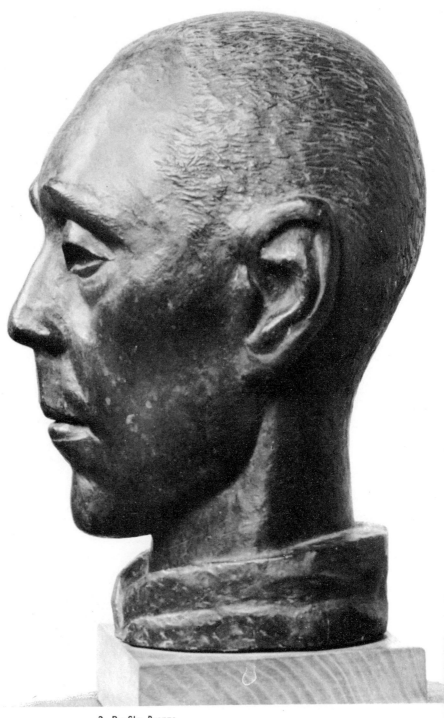

2. Profile. *Bronze.*

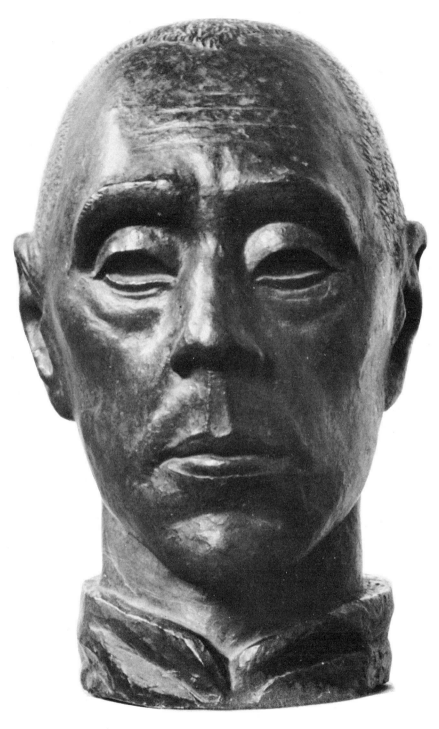

3. Front view. *Bronze.*

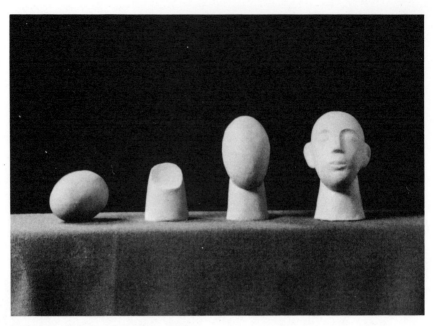

4. Exercise. Ovoid, and tapering cylinder.

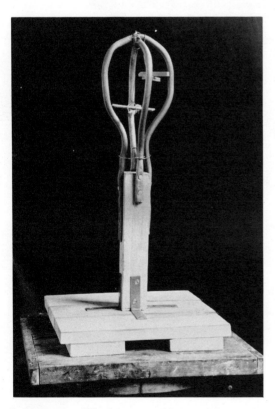

5. Armature. Wood, composition - piping, galvanized nails.

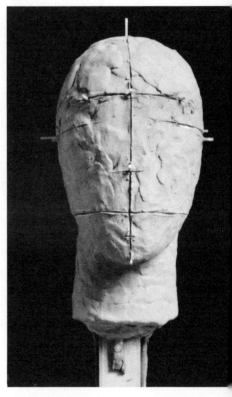

6. Basic-form. Clay over armature. Front view.

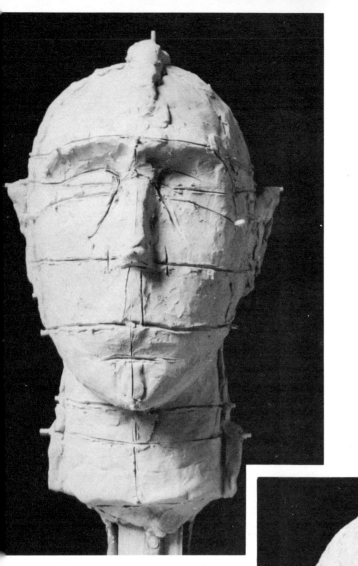

7. Basic-form. First stage development. Front view.

8. Basic-form. Second stage development. Front view.

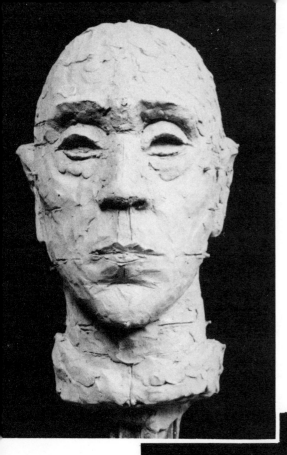

9. Third stage. Front view.

10. Fourth stage. Front view.

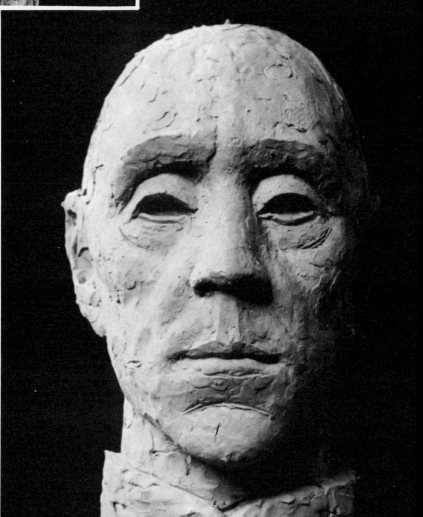

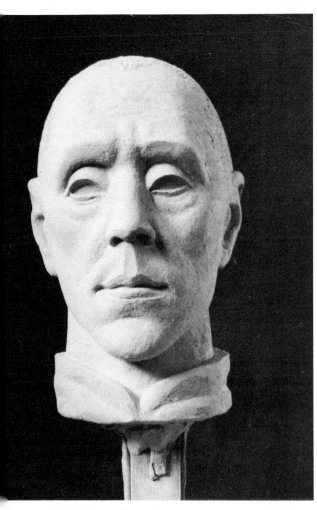

11. Final stage. Front view.

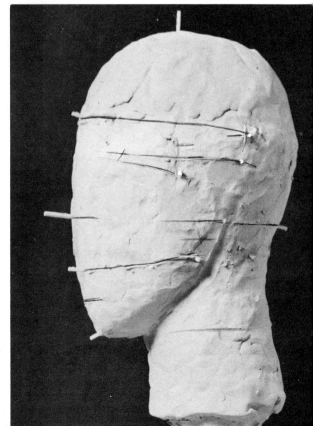

12. Basic-form. Clay over armature. Profile.

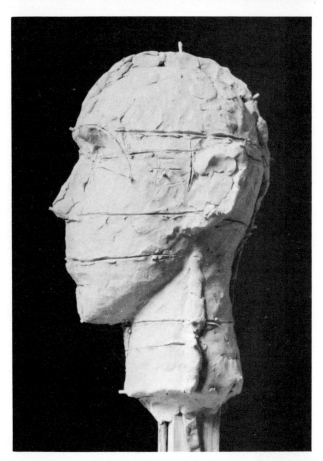

13. Basic-form. First stage development. Profile.

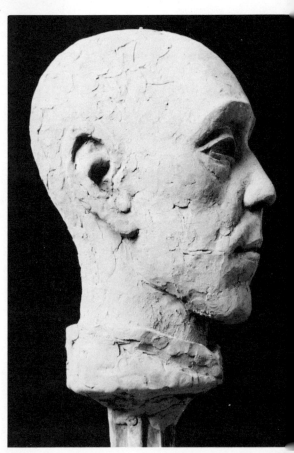

14. Second stage. Profile.

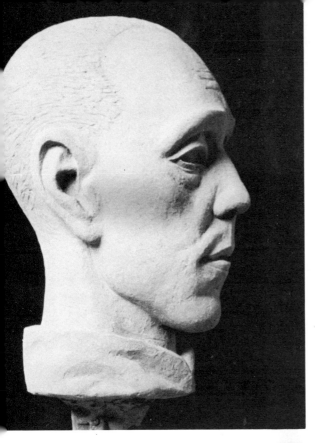

15. Final stage. Profile.

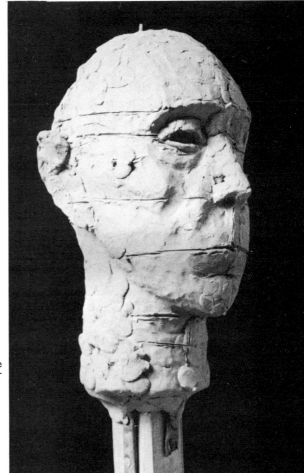

16. Basic - form. Second stage development. Three-quarter view.

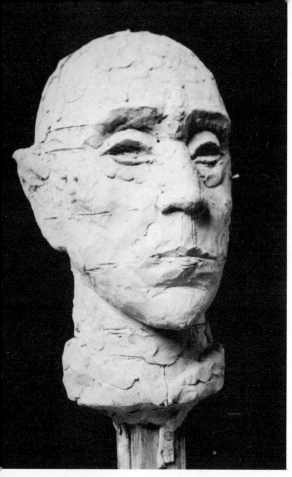

17. Third - stage. Three-quarter
view.

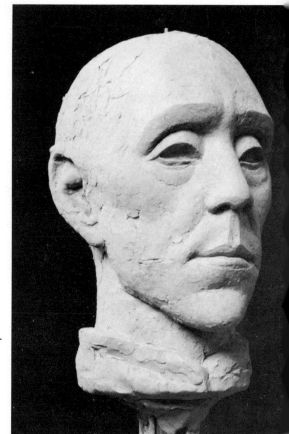

18. Fourth stage. Three - quarter
view.

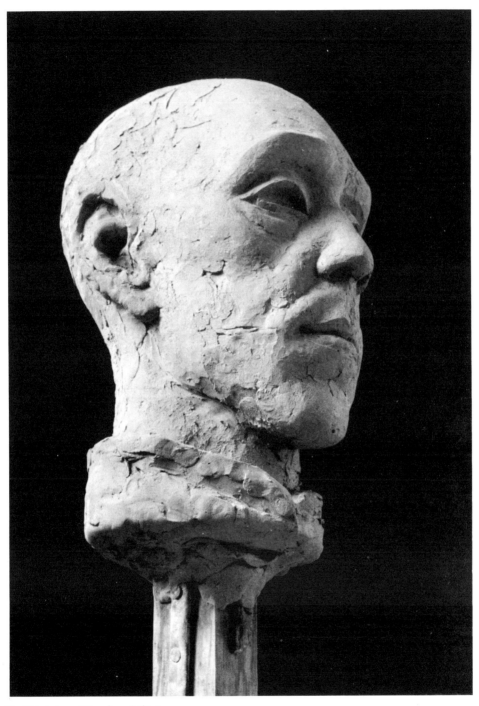

19. Third stage. View from below.

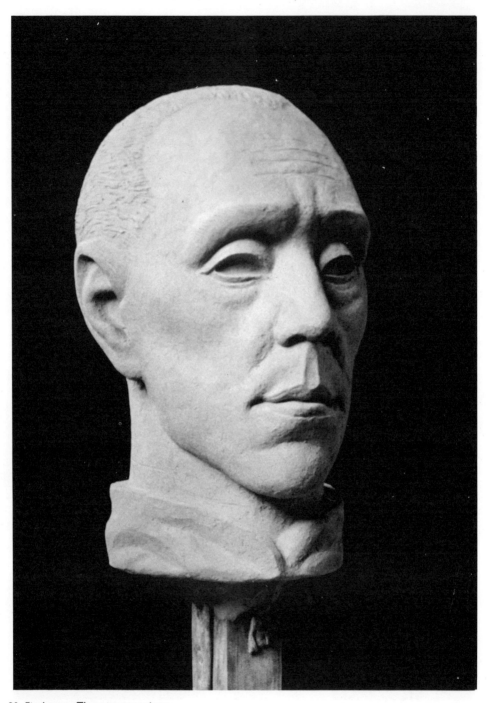

20. Final stage. Three-quarter view.

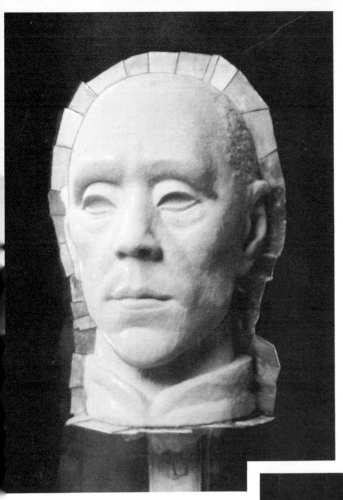

21. Fence of metal fixed in position for moulding. Front view.

22. Fence of metal fixed in position for moulding. Three-quarter view.

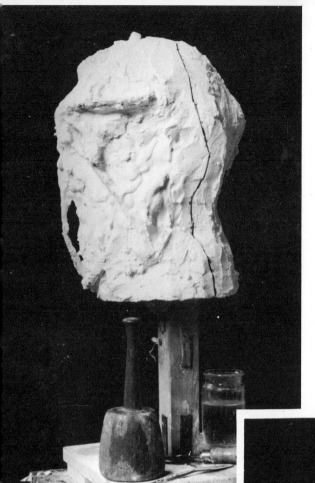

23. The completed mould
unopened.

24. The mould opened, with back
half removed.

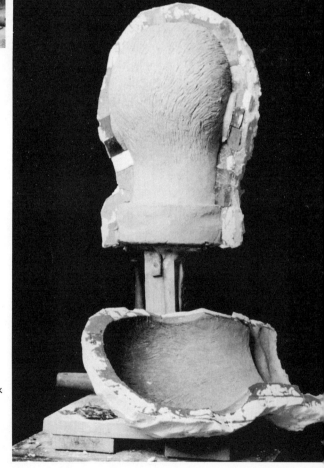

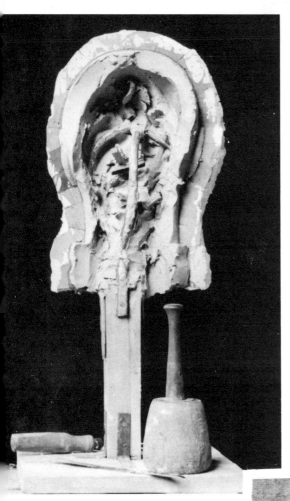

25. Removing the clay from the front mould.

26. The moulds freed from clay.

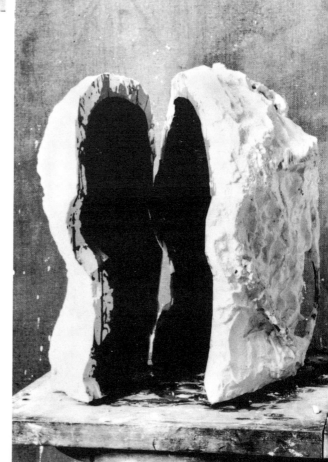

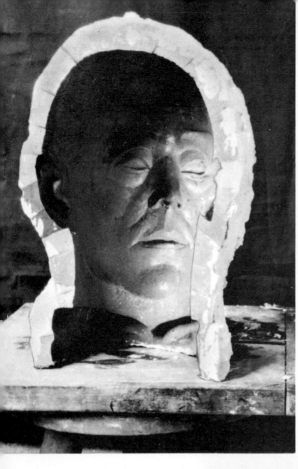

27. The front mould open and cleaned.

28. The mould tied together and filled. Ready for chipping out.

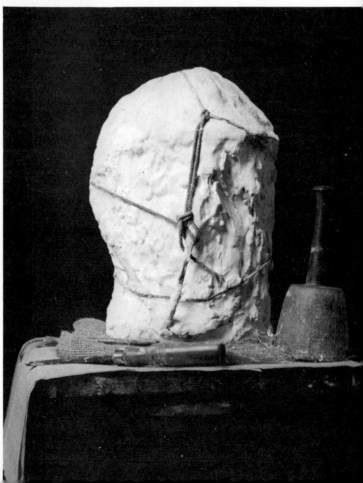

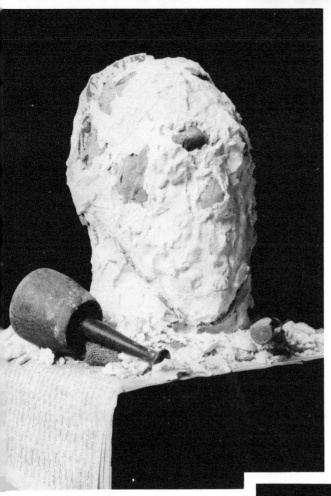

29. Chipping off the irons and outside coating.

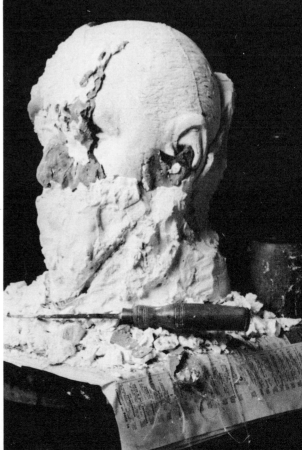

30. Freeing the upper part of cast.

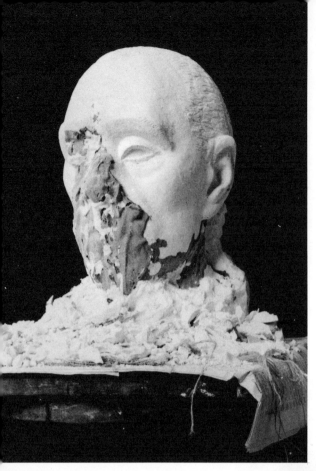

31. The cast emerging. Some coloured
coating and supporting mould
left on cast.

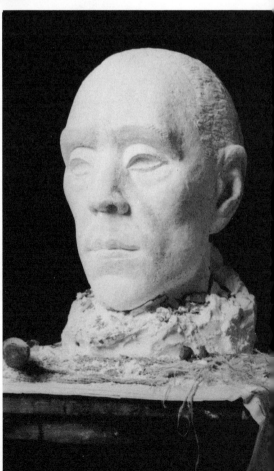

32. The head chipped out, but mould
around neck left on cast until
last thing.

been left almost in its first simple state—except for the fact that the added clay strip, marking the main front view silhouette, has been incorporated into the mass of the forehead when this was modelled earlier; likewise the strip down the side has been incorporated into the mass of the cheek; but the strip beside the neck and collar can still be seen clearly, as first applied to the outside of the original cylinder of the neck. The recession for the eye under the projection of the forehead can also be seen on this side.

On the other (left) side of the head in this illustration, however, the eye socket has been tentatively placed within the recession and some of the minor forms down the cheek indicated in relief. The nose on this side has also been developed further and the nostril built out with sufficient clarity for the shape of the cheek muscle, which runs beside it and into the side of the plane of the nose above it, to be suggested lightly. The cheek bone and also the sac below the eye have been indicated as well.

It will be noted that these forms hardly break the main ovoid shape—indeed the original horizontal section lines still show a little, here and there, on the surface. But the projection of the upper lip beneath the nose and the whole volume containing the mouth have been modelled back from the profile ridge, and down to the projecting upper ledge of the chin, and are incorporated into the main ovoid head shape.

The three-quarter left view illustration (Illus. 16, 17) of the head at nearly the same stage, should next be looked at and compared with both the three-quarter view and the front view of the head at a somewhat later state.

In this later state the mouth has been roughed in, the right side of the nose and cheek have been advanced to the same state as the left side, and the neck and collar have been similarly developed on the right side. The recessions above the eyes, and other forms, including the chin, have been built out a little more fully and the back of the head has been built up, until the volume of the head, at this stage of enlargement, has been re-established as a continuous form.

No attempt has been made to define completely any of the separate forms, but the head has been worked upon as it was moved round from position to position, and the smaller forms have been tentatively developed; firstly, by making slight hollows or cutting light planes, as for instance around the cheek bones, then by building up here and there as the different profiles presented themselves—but always with reference to the shape as a whole.

In the next stage illustrated (Illus. 10, 14, 18), although the head has been worked upon and developed from all angles as before, some of the smaller forms have been modelled with much greater precision.

The bridge of the nose has been modelled with the most careful attention to the receding planes at each side, more particularly where the junction between these planes

33

and the sockets of the eyes occur, so that the corners of each eye have been placed as exactly as possible in position and depth, in relation to the bridge of the nose. The characteristic angle of each eye as regards its horizontal axis has been established; the projection of the eyeball has been suggested by the prominence of the upper eyelid over the lower one.

The eyebrow line and the forms beneath it, above the eyes, have been developed and differentiated, giving character to the frontal overhang of the forehead. The mouth has been shaped more firmly and the muscular forms which surround and bind it at both corners, running across the upper lip towards the centre, have been more carefully defined. The cheek bones and the sides of the jaws, as well as the chin, have been built out and brought considerably nearer to their final dimension. (Illus. 18, 19.)

The neck has been worked upon, so that its short, but more massive, column-like form will balance the now enlarged, volume of the head; the general shape of the collar surrounding it has also been built out nearly to its final bulk.

None the less, no part of the head has been given its final form or finish; and all parts except some of the outermost projections such as the prominent upper edge of the cheek bones, the sides of the jaw, the projections of the forehead at eyebrow level and so on, have still been left spare of their ultimate dimension. They would still permit considerable modification both as regards disposition of surface modelling and manipulation of the surface texture.

Modelling the Head (2)

Before describing and illustrating what may be termed the development of the final state of this head, it might be advisable here to say a few words as to the treatment of the separate details, or features, of any head to be rendered in sculpture.

Other and more specialized books will deal more fully with this matter of the transposition of natural forms into sculptural terms, but at the outset the student may be faced with obvious difficulties of decision with regard to the treatment of eyes, hair, and mouth, where the colour and texture play such a prominent part in natural appearance.

In this book which is not at all specifically concerned with portraiture as such, the approach to natural form has been somewhat oblique; that is to say, only the essentially formal elements have been stressed from the outset. This is in no sense because of any lack of regard for portraiture in its most specialized sense, but because a realization of the formal element is the first essential to be considered.

If the student can, as he should, gain some working knowledge of anatomy this would help him to understand how the infinitely subtle arrangements of shape in the natural forms of the head are made up in reality, veiled and harmonized by the outer

covering of skin. A clear grasp of the bony structure of the skull and a simple knowledge of the muscular system which operates over it must always be very helpful, if not absolutely indispensable.

As regards the eye, there are many ways of suggesting its character in sculpture, apart from the ancient one of actually in-setting colour, by means of enamel or other colouring matter, into the eye sockets of a bronze; or by actually painting, with pigment of a more or less permanent character, sculptured heads made of stone, terra-cotta, or even plaster.

SECTION THROUGH EYE

The treatment of the eye, outside these attempts at illusion or decoration, will depend very considerably on suggesting the colour of the iris by creating tone or shadow upon the eyeball, beneath the upper lid. The character of this tonal treatment should be determined, largely, by the treatment of the head itself.

Where the head is formal in style, as in the one illustrated here, it will be consistent if the eye is also treated in a formal manner. The eyeball could have been fully modelled in the round and the iris and pupil indicated thereon by incising the surface, lightly or heavily, according to the depth of colour it was desired to suggest.

In fact, it has been treated here somewhat as in an archaic mass, the space between the upper and lower lids having been simply hollowed out. The general shadow cast in the opening was intended both to increase the rather formal appearance of the head and to help to give to it the somewhat enigmatic quality of expression suitable to the type.

It should perhaps be observed that in spite of the rather heavily hooded shadow under the lid which is shown in the final state of the head, the depth of the opening is in fact considerably less than might appear from the dark tone showing within. The overhang of the upper lid which forms part of the circumference of the sphere of the eyeball is continued in its curvature by the small lower eyelid. A slight drawing showing a vertical section through the eye will illustrate more clearly, perhaps, the depth of the actual opening containing the shadow (diagram). If this aperture is cut back too deeply it will be found that the strong colour of the shadow will separate itself too much from the general tonality of the head, and unity will be lost.

In whatever way the eye is treated later on, the important thing is to realize that the eye, open or closed, is itself a sphere in basic construction, and no matter how much broken may be the surface of the eyeball below the eyelids, in order to suggest colour, this idea of the spherical form must not be lost.

The lips in nature, also, look more sharply defined than they are in fact, on account

35

of their marked local colour. In formalizing their treatment in sculpture some added accent may be permitted in order to compensate for the loss of definition by colour. Whether this formalization is achieved by some use of incised line or by some accentuation of the modelling, the recessions and projections of the forms in the lips themselves must be shown as they occur along the horizontal axis of the whole mouth, which must, itself, conform to the horizontal section of the head at this level. That is to say, it must not be drawn flatly but, as it recedes from the centre, it should be modelled in depth in accordance with the curvature of the jaws in plan. Careful study of the mouth from below and also from the profile view will help greatly here and the illustrations, particularly of the head from below, should be studied at this stage, to examine these points. (Illus. 19.)

In completing this head, the separate forms and features were now given their full individual character. The mass and shape of the skull was developed to its full volume, as seen from all angles. The neck and collar were completed to make, in combination, a column with a surrounding base somewhat more rich and varied in its forms, in order to support the main shape of the finished head. (Illus. 11, 15, 20.)

The finished surface texture of the head, which was intended for bronze was obtained by the closer application of rather smaller pellets of soft clay as the features reached greater precision. The suggestion of close-cropped hair was given by the application of very small strips of clay, loosely put in place with the spatula and interspersed with slight, short incisions on the surface at small irregular intervals. Likewise, some short linear markings were made on the ridge of the eyebrows to give a little movement to the surface, differentiating the short hair growing here from the texture of the skin and adding a slightly decorative character to the whole surface. (Illus. 1, 2, 3.)

The treatment of the hair in sculpture should always receive careful attention— it can yield a great variety of colour and texture and also rhythm of design, where it is a prominent feature of the head. No attempt should be made, of course, to copy exactly the naturalistic texture of the hair, but the attempt should rather be made to establish in the clay, boldly and rhythmically, the general design of its masses.

Very often the depth of colour and the fineness or coarseness of the texture of the hair can be suggested by the shape and scale of the pellets, or strips of clay, which are used to form its basic masses in conjunction with the intervals of space between each application of clay. These intervals of space may be deep, giving darkness and suggesting strong tonal colour or slight, giving luminosity. There are infinite possibilities here, of course, for variety of texture as well as of form.

The student would be wise to study the best work of such sculptors as Rodin, Epstein, Despiau etc., for suggestive and vital treatment of the hair, in this sense. Where

a more formalized and conventional treatment is desired, there are a host of excellent and suggestive examples to inspire the student among the sculptured heads and busts from Egypt, Greece and Rome, through Medieval and Renaissance work, via Bourdelle and Maillol, down to the present day.

The question as to how far the hair should be simplified and incorporated into the general shape and volume of the head, or how far it should be treated as an added textural or decorative feature, giving richness and contrast to the more or less smooth surface of the rest of the head is, of course, an aesthetic one. This will be determined differently in the case of each work, by its formal or informal character—and of course, as with all such problems, integration of the whole work will be the aim. Singleness of purpose, taste and consciousness of the character of the work as a complete sculptural statement will be the guiding considerations.

In so far as the work approaches naturalism in intention and scale, such matters as the variety of edge where the hair makes junction with the skin—softly melting into it perhaps, at the sides of the forehead above the ears, more boldly patterned at the top of the forehead and so on—will have to be observed and registered.

In so far as the head is more strongly formalized or conventionalized, so may the hair be more strongly or rigidly patterned or simplified. Examples may be given but rules cannot be stated. The first necessity is to realize that the hair must be transposed into ordered rhythmical shape or texture, which will be part of a conception of the head seen as a single plastic whole; it must never be copied as a separate scratchy material attached to the scalp realistically.

In the head illustrated here, the hair is so closely cropped to the skull that it has been treated merely as a varied and partly linear clay texture—but as much value as possible has been given to the pattern which this all-over texture makes against the forehead, where it repeats and slightly emphasizes the rhythm of the eyebrows.

In writing thus far and showing by means of the illustrations the growth of a life-sized head in clay, certain unmentioned major assumptions have been made. The prime assumption has been that nature—with the infinite variety of forms at her disposal—can always set the original pattern for the artist; provided, of course, that he is capable of being stimulated towards the creation of art by things seen in the world of living matter. This is particularly true with reference to the modelling of the human head, where the variety of combinations of form is always infinite, in spite of a basic structure which is common to every head and the existence of certain types of head which may be broadly classified as belonging to similar groups.

In contemporary art, with the full assistance of contemporary art-criticism, the major

assumption just mentioned is challenged explicitly, perhaps for the first time in the history of art. Stated honestly, it is not now a question of the degree of deviation permissible from the pattern of form set by nature—but the setting up of entirely different aesthetic objectives. There is no place here to discuss the philosophy of aesthetics but the assumption made must be mentioned, lest the percipient reader should assume that the whole object of the author, so far, is to enable him to make a measurably exact and entirely objective image of whatever human model is in front of him—a by no means small technical achievement, anyway.

Let this much be said here: in practice, every form which is established and developed in combination with another form will, according to its shape, proportion and relationship, set up certain emotional responses in the onlooker, whether the onlooker be the actual sculptor or some other. As the work proceeds from simplicity to complexity, as it must if it is based on a human model—for the human visage is, surely, one of the most subtle arrangements of form with recognizably characteristic identity, in existence—not only will each form, developed or added to the shape previously established, modify or even alter that shape (bringing to it a new identity in greater or lesser degree), but with it also, there will arise at each development a somewhat changed aesthetic problem. A modification of the balance and design of the shape as a new whole, embodying the sculptor's aesthetic intention thus far established, will have to be considered afresh, and this consideration will influence each subsequent development of the clay figure as the work proceeds.

This further activity will imply, as every practical sculptor must appreciate, a series of selective modifications—or developments—as each step is made in building up the work. Every further stage of the work will imply a series of selections impelled, both consciously and unconsciously, by the sculptor's desire to create a shape which expresses both his feelings towards the subject matter in front of him and his urge to make an aesthetically satisfying shape. The balance of these forces at work within any particular sculptor will determine the identity of his work and express the personality of the sculptor, as well as that of the sitter as seen through his eyes.

This may be most clearly observed in any class of students working from the same living model. Each work, as it approaches finality, will develop its own separate identity as the continued selections from the original natural pattern (often quite instinctive choices) give different emphases to the final shape. The finished work will always show the sum of these selective developments of the modelling, which will also very definitely reveal the personality of the sculptor in the characterization of its form.

It might, of course, be possible, by pursuing the method of the projecting matchsticks described earlier to an overwhelming and absurd degree of mechanical exactness

(or by using any other method which will reproduce points, from all over the surface of the head which is being used as an original subject, on to the clay model), to limit the selective power of the sculptor beyond either sense or creativeness.

Even here, many factors such as surface finish, balance of forms in the clay model regarded as a whole, and treatment of the hair, eyes, lips and so on, would leave room for more considerable selectiveness and sensibility than the unpracticed would believe possible.

But beyond such trivial considerations altogether, is the fact that a living human head is an organic thing having great mobility and subtlety of form. This can only be apprehended and recreated as a sculptural unity by an almost intuitive grasp of the relationship of the parts to the whole, and a clear drive from within the sculptor to express and stress some aspect of the natural form as it first stimulated him.

According to his own make up he will inevitably accentuate, in his interpretation of the sitter, those aspects of character, and use those aesthetic considerations of design, which have impelled him to embark upon the work in the first instance.

The line between subjective and objective vision is a difficult one to draw. It has often been said that every portrait made by the artist also presents his own self-portrait. It will be found that notwithstanding the registration of some fundamental measurements, or the taking of some comparative measurements, as the work proceeds, none the less, the power of subjective selection is so strong, and the complexity of the structure of the head is so difficult to grasp in its entirety, that in actual practise the student should let no theoretical considerations—and such considerations abound today—prevent him from accepting the stimulus of natural form or inhibit him from studying it as closely as possible.

Nevertheless, the degree to which actual measurements should be used as a prop or discarded as a tie, will always be, to some extent, a matter of temperament. In the last resort the character of the sculpture will be determined by the order of the sculptor's will to form and, whatever be the method used, it is surprising to observe how strongly this order will always assert itself throughout the works of each individual sculptor.

PLASTER CASTING *chapter 5*

If the clay model were left to dry out it would first shrink and crack and then, probably, pieces of the hardened and brittle clay would break away. This is because the armature, which does not shrink, of course, has a fixed and unchangeable volume, while the clay surrounding it will shrink as the water within it evaporates; so that inevitably it must crack open, to greater or lesser degree, to accommodate the armature inside. Even without an armature inside it, any solid clay model will be extremely likely to crack as it dries, because of the uneven rate of shrinkage throughout its bulk—although full-size and solid busts of clay (without armatures inside) can be occasionally dried out success-fully and even permanently hardened into something like terra-cotta, in a light kiln.

For ordinary purposes, however, the model is always given more permanent form by making a replica of it in plaster. In this material, except for breakage, damp or other accidental causes of decay, the form may be considered to be an absolutely permanent one. There are plaster casts in existence dating back to ancient Egypt. The making of models for terra-cotta proper is outside the scope of this book.

In order to obtain a replica of the work in plaster it will be necessary to take from the clay model exact moulds, which may then be filled, or coated all over inside, with a sufficient thickness of liquid plaster of Paris, to take the impress of the moulds precisely, as it sets. It must then be possible to remove the moulds, leaving the replica of the clay model—now in plaster—standing freely.

A waste-mould is so called, because its removal from the plaster cast within, involves breaking away the mould piece by piece; the mould is thus destroyed in the process and it is only possible to obtain one replica of the original model by this method. It is none the less the most usual method for sculptors to employ, in giving permanence to their work in clay. It is a very exact and simple method and the mould may be made directly on to the surface of the clay, without the use of any dressing such as would be necessary in preparing it for gelatine moulding, for instance.

To make a waste-mould of a head it will be necessary to make the mould in two pieces, so that one piece may be easily removed and the clay and armature extracted from the other half, without injury to either piece.

40

It will be important later to have sufficient access to the interior face of both halves of the mould, in order to clean them thoroughly and remove any clay left in undercuts, and also to prepare the surface before they are put together again, so that fresh plaster may be poured in to form the replica, or cast, of the clay model.

There are two chief methods of waste-moulding a head. The mould may be divided by making a "pot-lid"—that is to say, a more or less circular or oval piece, some 5 to 7 inches in diameter, may be made at the back of the head and the rest of the head can then be moulded in one piece—or the mould may be divided by a line running over the top of the head and down both sides of it, on or behind the ears preferably, and down the sides of the neck to the base; so that the moulds may be made both sides of this line and contiguous to each other upon it.

The "pot-lid" method is suitable in some cases and simpler, in so far as the rest of the head is moulded in one piece. This mould is less liable to warp or twist; also, the seam on the cast where the moulds are divided will be a very small one in length and in a position at the back of the head where it is little visible and easily removed.

As against these advantages, however, the removal of the clay and armature from the mould may be more complicated and difficult for the beginner, and the cleaning of any concealed undercuts in the face of the mould and the preparation of its surface before filling, may prove less simple because of the difficulties in getting direct visible access.

The other and perhaps more usual method of dividing the mould into two uneven halves at a line running up and over the head, is the one to be used and described here.

Materials and Equipment for Waste-Moulding a Head

The plaster of Paris which is used for casting sculpture, derives its name from the fact that it was first brought to this country from Paris, where there are important gypsum quarries in the Montmartre district. It is made by burning gypsum—a whitish mineral consisting of sulphate of lime and water. This burning or calcinating drives off the water and reduces the gypsum to a fine powder, which, as plaster of Paris, will again solidify into a hard material when suitably mixed with the right quantity of water.

Different qualities of plaster may be obtained. The pink or light brown, coarse, builders' plaster is no use for casting.

The superfine quality which is used for casting sculpture is made from picked raw material and is pure white in colour. It is usually called "Fine" or "Superfine Dental Plaster". It is sold in seven pound bags and may be obtained at most large suppliers of artist's materials and at some general paint and builders' merchants; better still, it may be

bought at suppliers of sculptors' materials or manufacturers of plaster of Paris, where it may be obtained also, in fourteen pound bags or by the hundredweight, sometimes in air-tight cartons.

The chemical action by which water and plaster of Paris combine into a hard substance, makes the plaster very sensitive to moisture. It absorbs moisture from the air with extreme readiness, for instance, and must therefore be kept in an air-tight tin for storage, or it will soon become useless. Once the chemical action has taken place it is useless for the purpose of casting.

It is always advisable, therefore, to test out the plaster before using, by mixing a small quantity with water and leaving it long enough to set hard. Note should be taken of the time this process takes as it will prove a useful guide afterwards, when moulding and casting. Its speed of setting decreases as it absorbs moisture from the air, up to the point where it is altogether spent and quite useless. But between absolute freshness, where its quick action may be uncomfortable for the beginner to work with, and the point where it is useless by reason of its chemical action being already spent, there is considerable variance in the time to be allowed for setting properly.

To test it out before using is the most practical procedure. The chemical action which hardens the mixture will only take place once, of course, and even to break down its structure by remixing, when it is really beginning to set, will greatly weaken the constitution of the final material.

Having obtained a sufficient quantity of plaster and having tested it (five seven pound bags should be more than ample to mould and cast the head illustrated, which measures just 13 inches in height from the bottom of the collar to the top of the head; this would leave plenty of plaster over in the fifth bag for unexpected contingencies—indeed it could easily be done with four seven pound bags, but it is always better to have some plaster to spare for the small extra outlay, in case of accidents), it may be as well to enumerate the other equipment to be used when casting a head.

The first necessity is a bowl or bowls in which to mix the plaster. For this purpose an ordinary white earthenware kitchen basin which can be obtained cheaply at any household store is excellent—a good size, useful for heads and busts, measures 6 inches in diameter at the top rim and stands about 4 inches high. The quantity of plaster to be mixed in a bowl of this size can be controlled easily and will give a fair surface spread when in liquid form, leaving time for consideration before setting takes place. It may be helpful also to get one bowl of smaller size for any lesser mixing and a larger bowl in which to mix greater quantities—but the size mentioned here is perfectly adequate to carry out the whole job being demonstrated.

At least two plaster tools will be necessary, one large and one small. These tools are

made of steel. One end of the large one should be a spatula which is usually made slightly flexible, the other end is shaped like a thin leaf with the point turned up and is quite rigid. The outer edges of the leaf are usually very sharp and may be used for cutting and scraping plaster when hard (see diagram, page 14.)

As with modelling tools, there is a vast assortment of shapes to be obtained and practise will, as before, disclose to the student which shapes are likely to prove favourites; but it is not necessary to have more than the bare minimum to commence with. In addition to the two tools mentioned, a particularly useful one is a steel tool with a thin leaf shape at both ends; one end has the leaf turned upwards as before and the other end has the point turned outwards at one side—but both these leaves have a fine serrated tooth all round the edge. This is a very useful tool for cutting or scraping plaster when set hard and gives to it a roughened texture which will hold tightly to any fresh plaster applied to its surface.

A large kitchen spoon will be required for mixing the plaster.

A few lengths of iron, square or round in section, will prove very useful for strengthening the mould. The section to be used if bought new, can vary from a $\frac{1}{4}$ inch to 1 inch according to the size of the job—for the present work a $\frac{1}{4}$ inch section will be sufficient. It will prove more easy to bend an iron of this small section into something like the required shape than one with a thicker section. One or two upright pieces and two or three horizontal pieces should be ample with which to reinforce the front mould; one upright and two horizontals should amply suffice for the back mould. As the process of waste-moulding a head is further described the use of the irons as a means of reinforcing the moulds will become more clear.

Likewise it will be easier later on to assess the length of the irons to be used. These will have to be bent, roughly, to follow the shape of the moulds, both vertically and horizontally. The idea of the use of irons is to form a rigid supporting cage or framework for each mould—to surround the mould and to be incorporated with it.

This iron may be bought by the length, in various thicknesses, and is usually sold by weight. It may be cut into shorter lengths with a small metal saw as required and bent roughly, with some effort, to the contours of the mould.

Once again, to grasp the general principle will be the important thing. The use of irons gives strength and will help to prevent the mould swelling when filled with the fresh plaster which will form the cast. It will also reinforce any weakness in the moulds, which can otherwise sometimes break; particularly so when they are being levered apart for the first time in order to open them, while they are still tightly enclosing the clay model. Indeed, in some moulds where the curvature makes the shape a weak one, the support of some irons is indispensable; always, irons are useful in strengthening moulds

43

of any size or depth. The chemical action of setting heats the plaster and tends to swell it and the irons will help to counteract this effect.

None the less the use of irons, and more particularly their precise size and positioning can easily become a fetish. As in all such matters of expertize, understanding of the necessities involved and an ability to recognize where a weakness in the mould is likely to occur are the important things, and this will only be likely to come with experience. The author has cast many heads and small figures quite successfully without using irons at all, or using them very sparingly where a weakness in the mould has suggested that it would definitely require reinforcement.

In practice, also, nearly every sculptor has a collection of odd irons of various shapes, which have to do service almost over a life-time. A little ingenuity and understanding will generally enable the student to use any odd lengths of iron easily accessible, preferably just pliant enough to be bent into something near the outside curvature of the mould needing support. This curvature need not be at all exact and the irons used may have been originally thin window bars or anything else whatsoever, so long as they will serve their purpose.

For the beginner it will perhaps be simpler if he purchases some new square or round iron, $\frac{1}{4}$ inch section, and cuts it, or has it cut, into suitable lengths to enable him to make a very open outer cage or framework, which will be incorporated into the outside coat of each plaster mould. These irons can be cut and then bent somewhat to the shape of the clay model, so that they are ready to hand before the plaster moulding is begun. One vertical and two or three horizontals should be quite adequate for the front mould of a head such as the one illustrated; one vertical and two horizontals should be sufficient for the much smaller back mould—in fact, only one upright iron was used to reinforce the back mould in casting the head illustrated and to help to take the leverage when removing it from the clay model—and no horizontals were used on this part of the mould at all. But for the beginner, it is perhaps better, when in doubt, to be on the safe side and reinforce fully with irons.

It should be remembered that any concave curve in the mould—for instance the curve at the back of the head and neck, is liable to fracture when removing it from the clay model.

A soft, long-haired brush will be used in cleaning out and preparing the inside of the empty mould. Some pure green soft-soap which can be bought at any chemists and a very small quantity of pure olive oil will be used for the same purpose.

Some strong cord, with which to tie the moulds together before filling them, should be obtained.

A strong knife will be necessary to trim the edges of the mould.

Some powder colour—yellow ochre, burnt umber, or light red—will be used to tint the first coat of plaster.

Finally, some very thin brass sheeting—copper serves excellently, also—must be bought, to be cut into strips about an inch wide with scissors. These strips will be used to make a fence dividing the two halves of the mould.

A good supply of water near to hand will be very important. It must be remembered that liquid plaster soon hardens and must on no account be allowed to run down the sink, nor must any residue of plaster from cleansing bowls, tools or the like be allowed to go down. Plaster in any form will most certainly stop it up.

The basin to be used for mixing the plaster will need to be washed out and cleansed before each fresh supply is mixed. The most convenient way to do this without risk of stopping up the sink is, perhaps, to have nearby a small galvanized bath, or some such, three-quarters full of water (with a good covering of old newspapers underneath the bath) and to use this bath for the sole purpose of loosening and cleansing the inevitable hardened skin of plaster from the bowl, etc., as the work proceeds. When the moulding and casting have been completed the water can be carefully poured off and the residue of waste plaster turned out on to newspapers or the like, and disposed of. The water in this bath must of course, on no account be used for mixing fresh plaster—for this purpose fresh, uncontaminated water must always be used.

No matter how carefully it is done, moulding and casting is a dirty job and precautions against the mess it will cause should be taken before the work is begun.

A large supply of old newspapers will be immensely helpful. These should be fixed right over the lower part of the armature upright and base-board. They should also be placed to hang over and to cover the whole modelling stand. Some little damping of the papers will make them more pliable for this purpose and they may be held in place with drawing-pins. The floor also, should be well covered.

Having arranged the room or studio with the maximum of protection (any sort of high screen which will not be injured by splashes, or which can be protected by a covering of newspapers will be very useful if placed directly behind the work), and having collected the necessary material and tools together and arranged them in easily accessible order, the clay model can now be prepared for moulding.

WASTE-MOULDING
THE HEAD

chapter 6

It will first be necessary to make a fence on the model with the strips of brass sheeting in order to divide the mould into two halves.

In casting the head illustrated here, the fence was fixed on a line running over the top of the head and just behind and touching the back of the ears, and then down both sides of the neck, thus dividing the mould into two unequal halves—a small back mould which would open and pull away easily, and a large front mould containing most of the deep modelling and undercuts on the head.

To make this fence, pieces of the brass sheeting (copper would have done equally well) about 1 inch wide were cut with a pair of scissors into uneven lengths varying from about $\frac{1}{2}$ inch to 2 inches. The ends were cut so that they would taper slightly inwards. These pieces were then firmly and cleanly inserted into the clay, placed end to end, the slight inward inclination of the ends helping them to fit more easily around the curved surface of the head. The pieces were inserted for the most part at about a right-angle to the surface. (See illus. 21, 22.)

Some care should always be taken to consider the angle to the surface at which the fence is to be fixed, as there could be some difficulty in opening the mould from the back if the brasses are set at too acute an angle with the surface of the clay. The line right round the head made by the brasses need not be too regular, as some changes of facet and direction in its continuity will enable the two moulds to fit together again more exactly when empty.

Some sculptors make a key to ensure the accurate fitting of the moulds by bending an occasional piece of brass round a pencil, or other such shaped piece of wood, and placing these key brasses at intervals round the fence, say four or five spaced round the whole fence, for a head of this size. The plaster which is placed on both sides of the fence, in making the moulds, will then form a projection on the concave side of such key pieces and a sinking on the convex side. These keys will fit into each other when the empty moulds are tied together, thus ensuring an absolute register.

A simpler alternative to shaping the pieces of brass, which can sometimes prove brittle, is to make keys by varying the line of brass fencing with some small, shallow

46

V shapes made up each of two ⅜ inch lengths of the brass strip, placed together upright edge to edge and spaced at regular intervals as before, round the fence. This precaution should certainly be taken when the line of the fence dividing the two halves of the mould is a very flat one right round.

The author has always found that an exact register can be sufficiently assured by slightly varying the line round the head, as for instance, where the line of the fence recedes a little behind the ears in the moulding of the present head. This change of direction, added to the slight irregularity of facet in placing the brass shims, which usually occurs anyway, can always be made use of intentionally, when erecting the fence. But where any doubt exists it would be wise to shape a few brass shims and make a key so that the moulds will register exactly, beyond any possible doubt.

It will be noted in the illustration that a ledge of the metal pieces has also been placed just beneath the collar—this will help to catch the liquid plaster, when the first coats of the mould are being applied to the clay model. It will also give to the beginner some indication of the thickness of the mould at the base. It is not at all indispensable to make this ledge of metal, but a ledge of some sort to catch any surplus plaster running down can be very helpful.

(For those readers unable to obtain the thin metal sheeting, an alternative and older method of making a dividing fence is to use strips of clay instead of metal; but each mould will have to be completed separately by this method.

The strips should be about a ¼ inch thick, and cut out of the flattened clay with a knife in the way that pastry is cut. If these strips are made somewhere about 8 inches long and 1 inch wide, they can be laid firmly round the head standing on edge, and following the same line of division as the brass fence.

But in this case the fence of clay will probably need to be supported, either by some very thin and small skewers of wood or wire, stuck into the head behind the fence at intervals; or by some small supporting buttresses made from triangles of the flattened clay placed firmly against the fence at the back and standing out from it edgeways upon the head.

These supports will prevent the clay fence from being moved when the weight of plaster to form the front mould is thrown against it.

The moulds will now have to be made as described later, and completed one by one; the larger front mould should be made first of course, as the supports for the fence were put at the back of it. Some damp newspaper can be laid lightly over the back of the head while the front mould is being made; this will protect it from splashes of plaster.

As soon as the front mould has been made and when the plaster has set, the clay fence

47

will have to be removed—also, of course, any clay buttresses or other supports which have been placed behind it to prevent it from moving.

The outer edge of the mould will have to be trimmed clean with a knife and a little of the surface around it will have to be smoothed also, so that it presents a clean, craftsmanlike edge for the back mould to join on to it.

Some key sinkings must now be made all round the surface of this edge, for the clay fence is likely to make a much more flat edge round each piece of mould where these will touch each other, than would the brass shims. Such keys are best formed by making some shallow circular sinkings at intervals of about 6 inches along the edge—these sinkings should be clean and without undercuts, with their greatest depth in the centre. They can be made with the point of a knife or steel spatula and they should be interspersed with some shallow V cuts, also, around the outside edge.

The whole of this edge of the front mould including the key sinkings should be thoroughly brushed all over with some soap or clay water, including part of the outside of the front mould adjacent to the edge, where this has been trimmed and smoothed. This soap or clay water is to prevent the back mould sticking to it.

Then the back mould should be made exactly as will be described later, not forgetting to put the powder colour into the first coat. When this back mould has set hard, the plaster should be scraped down to disclose very clearly the line where the moulds join together. The sinkings and the V cuts made on the edge of the front mould will now have their counterpart projections on the edge of the back mould, thus ensuring a complete register when the moulds are put together again.

The opening and filling of the moulds will, of course, be done exactly as described later. This method is also particularly suitable for very small models which might be injured by the insertion of a metal fence.)

Having erected the fence of brass shims and having made sure that the brasses are inserted firmly into the clay, so that they project about $\frac{3}{4}$ of an inch all round the head, pour some fresh water (not from the water in the galvanized bath, which is to be kept purely for cleansing) into the earthenware bowl, filling it to about two-thirds of its capacity. Into this water put some of the powder colour with a spoon and stir it up well.

The colour is put into the water so that the first coat of plaster in contact with the model can be differentiated from the subsequent coats by reason of its different tint, when the moulds are being chipped off the cast later on. It will be necessary to make this tinted water quite a lot darker than will be required in the set plaster, as the white plaster which is to be mixed with it will lighten it very considerably.

All is now ready for the first mixing of plaster.

Mixing Plaster

Now take a handful of plaster from the bag—this plaster should have been previously tested for freshness—and quickly but steadily, sift it through the fingers into the coloured water, using a slightly circular movement to spread it fairly evenly. If there are any hard lumps in the plaster, of course, do not let these get into the water.

The object of sifting the plaster through the fingers is to let it descend into the water lightly and not in heavy masses, and also to reject any hard lumps, so that the water can soak through it quickly and easily without causing bubbles.

Repeat this operation very speedily until the plaster forms a little mound just above the surface of the water in the centre of the bowl. In a moment or two the water will soak through this tiny mound. Then take the spoon and plunging it right down to the bottom of the bowl, stir, or rather beat the plaster and water together with a quiet, swift, circular movement without bringing the spoon to the surface. This is important, so that the spoon will not take down air with it and form air bubbles.

When it is thoroughly mixed, but not over mixed, withdraw the spoon and leave the mixed plaster standing just a few moments. Then skim off any air bubbles or scum which may have come to the top and throw them aside. Let the mixture stand for another few moments, by which time the plaster should be about the consistency of cream and ready for use.

Holding the bowl in one hand, dip the lower part of the other hand, with fingers curved upwards and the back of the hand facing the clay model, into the bowl of mixed plaster and with a forward movement steadily throw, or sprinkle, a coating of the liquid plaster all over the model. To do this it is best to begin at the top of the head in front of the fence, working down to the base evenly, and then cover the back half of the head behind the fence in the same way; so that the whole head will have had one good coat of the tinted plaster covering it.

This operation will have to be conducted speedily and deliberately and with full attention. Where there are undercuts, or the wet plaster does not seem to cover because of more complicated modelling (as for instance over mouth, eyes, nostrils, etc.) do not hesitate to blow the wet plaster good and hard, in order to spread it thoroughly over every surface and to guide and push it into every crevice.

Leave this first coat of plaster as rough as possible so that the next coat will adhere to it. If it seems too smooth, throw on a few extra blobs of plaster here and there to roughen it and to give the next coat a good hold—but of course do not touch the surface with the fingers or the face of the clay underneath may well be disturbed (see Illus. 51).

If the first bowlful of plaster is insufficient to cover (it will not be sufficient if the head

49

is life-size), of course the bowl must be washed out before mixing fresh plaster in it, by plunging it into the small galvanized bath or other receptacle full of water for that purpose, and all superfluous plaster must be quickly loosened and removed. Mix the fresh plaster with coloured water again and continue as before until the head is completely covered with one coat of the tinted plaster. This coat should be, approximately, a $\frac{1}{4}$ inch thick.

It is possible, of course, when more practised, to mix sufficient plaster at the outset in one large bowl to cover the whole head, and to keep taking liquid plaster from it with the smaller bowl; but, if you are a beginner, the chances are that much of the plaster mixed in the larger bowl will have begun setting by the time you have used up a small bowlful or two and before the head is covered, and the remaining plaster in the larger bowl will have to be wasted. On balance it is much better for the beginner to use the one bowl and mix afresh as required.

As soon as the head has been covered by one coat of the coloured plaster it should be left to set—which it should do in not more than fifteen minutes. Then, take a brush with a little clay water—that is, a wet brush lightly rubbed on to a lump of clay, or a brush dipped into a solution of clay mixed very thinly with water—and daub patches of the plaster with it, here and there, over the surface. This is done so that, when the outer coats of white plaster mould are being finally chipped away, they will come away very freely from this first coloured-plaster coating, which now will be touching the surface of the clay model (and later, of course, will touch the surface of the cast). Do not place these daubs of clay water too near the brass fence, though, as it will be advisable for the mould to be very strong and compact here.

Now mix the plaster as before, but without adding any colour to the water, and continue to build up the outside of the mould all over. It will be better to leave the mixed plaster to stand a little longer before using during this operation, so that it can thicken up a little—it will be less inclined to run off the surface of the mould and be wasted, and in this state it can be placed more easily just where it is required; but of course the plaster must on no account be left to stand until it is really "going off"—that is to say, so thickened that it is partially set and has to be broken down and re-mixed. In this case it would be very weak when set or it might not even set at all.

This second coat of plaster should be rather thicker than the first coat, particularly over prominent parts such as the nose, chin, eyebrows and round the outside edge of the mould touching the brass fence.

While this second coat is setting, take some lengths of iron and bend them as nearly as possible to the shape of the mould. For the front mould one vertical iron can be placed centrally, from the top of the head to the bottom of the base, and two or three horizontal

pieces can be placed at regular intervals down the mould, bent as nearly as possible in each case to follow the shape of the mould—if you have already prepared these roughly, using the clay model as a guide beforehand—so much the better; you can now actually try out each iron in position by holding it against the face of the mould as soon as the plaster is set.

It is not necessary that these irons should fit the mould exactly, but they should be able to make good contact with the face of the mould at their ends and at a few points along their length, certainly—preferably where the horizontals and verticals will cross each other.

Mix another bowlful of plaster, but this time let it stand until quite thick, then fix each iron quickly into position on the outside of the mould by placing a good solid blob of plaster at each end of the iron and also at such other places where it makes contact with the surface of the mould. It will be necessary to hold each iron in position separately, until the plaster blobs set sufficiently to secure the iron to the mould. Where one iron crosses another, blobs of plaster should also be added to the junction of the irons and to the surface of the mould beneath. These blobs of plaster can be moulded into position lightly and quickly as they set, with the aid of the large steel spatula.

Another way of fixing the irons is to buy some "scrim", which is a very open-weave hessian canvas used by plasterers (a yard or even half-a-yard will be sufficient) and cut some of it into strips a few inches long. Dip each of these strips into a bowl of mixed plaster when it is just beginning to thicken and, when fully soaked with plaster, twist it loosely round the iron at any point where the iron is to be attached to the mould. Spread the mesh out flat on both sides, patting it down on to the surface of the mould and quickly cover it with some further plaster. These ties of scrim, soaked in plaster, will hold very firmly as soon as the plaster sets and they can be extremely useful for any such operation —but also, by the same token, they will be rather tenacious later and may prove some-what more difficult to remove from the mould when taking off the irons. For this reason this method is not particularly recommended for the beginner.

Pieces of scrim soaked in plaster and laid flatly on to the inside of the cast may also act as a very helpful lining in strengthening it—particularly where the neck or any other slight part in a thin cast needs support.

Once the irons are fixed in position on the moulds (and it will be well not to touch the irons or to shake the mould until the blobs of plaster holding them are set fairly hard) then with some fairly thick plaster, build up the outside of the moulds with a final coat and while doing this incorporate the irons more firmly into it.

It will not matter at all if the irons protrude here and there, so long as they are fixed firmly—indeed, the protruding part of an iron can be very useful in giving a good hold

for the cords which will, later, tie the moulds together (but the ends of irons and other points of contact should be firmly embedded in the plaster and covered by this last coat).

It will be found that this last, outside coat of plaster can be used fairly stiff—just before it is setting—and can be built up more easily thus, using a large steel spatula for the most part.

The completed plaster mould should be, roughly, not less than ¾ inch average thickness and should be built up to the full depth of the fence all round at the edges and the base, where it needs to be strong. Care should be taken to ensure that any prominences in the modelling are well covered. (Illus. 23.)

The thin outer edge of the brass fence will almost certainly be lost to sight underneath the last coat of plaster and as soon as this plaster on the completed moulds is beginning to set hard, this line showing the top edge of the brass fence should be found again by scraping down the plaster above it with a knife. Once disclosed the fine brass line must be followed and uncovered right round the mould.

By using the knife across the top of the first section of the metal line to be disclosed, and continuing to scrape or cut the plaster vigorously, down to its level, a clean plane of the plaster may easily be established running right round the head, with the fine line of the metal showing in the middle where the two halves of the mould touch. (Illus. 23.)

Once the mould has been thus cleaned up and prepared for opening, it will be as well to remove the newspapers from the base and stand, and to clean up any waste plaster thereon.

Let the moulds set thoroughly before attempting to open them—this should take place within about half-an-hour, during which time everything can be cleaned up, around.

In order to open the mould, take up a wooden mallet or a light hammer and a broad, blunt chisel. Place a glass or jam-jar full of water, on the base-board. Standing above the model and at the back of it, insert the chisel very slightly at the top of the mould, just behind the brass fencing where the plaster touches it. Tap the head of the chisel very lightly indeed with the mallet or hammer, and repeat the operation at some point on each side in the joint (avoiding, carefully, any position where keys may have been placed along the fence), so that the chisel has the very slightest leverage against the fence in the joint at these points. Now re-insert the chisel at the top position (do not, on any account, attempt to make a large gash in the plaster at any of these positions or use any strong leverage whatsoever) and while using the gentlest leverage possible, pour right over and into the joint, here, a good part of the water in the jam-jar.

This will swell and soften the clay within, and with a little judicious leverage the back mould should soon show signs of opening easily. Do not attempt to force this

operation, but try a slight leverage with the chisel in each position in turn, and if the mould still seems tight, pour some more water in from the top.

Once the mould seems to loosen, a little patient movement, holding the back mould in both hands, should soon free it completely. It is in this opening of the back mould that the usefulness of the irons will be demonstrated, particularly the vertical one used here in the centre of the mould; for, in taking the weight of the leverage it should prevent any tendency of the mould to break across. This would be more certainly the case if there were any considerable undercuts to be negotiated in releasing the mould, as for instance beneath hair overhanging the neck, or the like. The head illustrated here had a very simple back mould which lifted away with very great ease. (Illus. 24.)

Having removed the back mould and placed it down, face upwards, in some place where there will be no liability of accident, remove all the brass pieces from both moulds as these metal pieces can, of course, be used again.

The clay must now be removed from the front mould. This is best done by hollowing out the clay all round the armature, leaving a covering of clay at least an inch thick touching the actual face of the mould. The rigid curved leaf-end of the large steel spatula or any other suitable tool may be used to help here to scoop out the clay—but of course care must be taken not to dig too deeply into the clay with the point, in case it should scrape the surface of the mould.

Once the armature has been more or less freed, it may be pulled back—also the butterflies (see illus. 25). When a little more clay has been removed from the neck, the front mould with the remaining clay in it can be lifted off the armature and laid down on its back. The rest of the clay may then be more easily removed. It is best not to attempt to pull out the clay in too large lumps, or delicate undercuts such as the nostrils (which will now be projections on the face of the mould), may very easily be broken and pulled away with the clay, especially if it has hardened. Once the main mass of clay is so hollowed that the remainder forms only a comparatively thin covering in the mould it will be quite a simple matter to remove the rest. Where clay has been trapped into any deep crevice it may have to be picked out carefully with a wooden tool; sometimes a larger lump of soft clay, held in the hand and pressed on to the recalcitrant piece will attach it to the larger lump and help to remove it.

As soon as the clay has been cleared from the moulds, the surfaces, which will always hold a little clay (especially where there is any sharp texture) will have to be thoroughly cleansed. This is best done by laying each mould in the sink under a tap and letting some water run over it, while using a soft brush and some soap. Care will have to be exercised so as not to injure the surface of the mould as the plaster will be fresh and will not withstand rubbing with too much friction. (Illus. 26-27.)

When the mould is clean a mixture may be made by first putting a tablespoonful of the soft-soap into a cup nearly full of very hot water and stirring until this dissolves. A small teaspoonful (or an eggspoonful) of the olive oil should be added to the mixture, which must then be thoroughly stirred together again.

When this mixture has become cool the interior of the moulds should be lathered with it all over. Keep squeezing out the brush with the fingers and removing any of the used lather which remains on the surface of the mould, and then repeat the operation with some fresh soap mixture. Continue to do this over every inch of the surface for about twenty minutes until the mould has been repeatedly treated all over. Then carefully remove with the brush all trace of superfluous soap and lather which may remain on the face of the mould; remove it particularly from any crevices, for it would be likely to spoil the surface of any fresh plaster poured into the mould later to form the cast.

In all the cleansing operations a very soft sponge can be a helpful adjunct, but it is better to carry out the final operation of soaping the mould with a soft brush.

When the moulds have been thoroughly prepared with the soft-soap and oil mixture, the surface should be sufficiently saturated to be just non-absorbent for water and having something like an egg-shell finish rather than a high gloss.

The two moulds—or rather the two halves of the complete mould—must now be put together very exactly and tied in position with very strong cord or thin rope.

The join where the two moulds meet should be carefully examined all round to ensure that they are exactly registered, or keyed, together. The cord must be tied right round the mould in two or three places, very firmly, so that there is no possibility of its loosening. Any projecting loop of iron in the mould may be utilised in preventing the cords from slipping down the moulds or in otherwise securing them.

If there is any difficulty in tightening the rings of cord running round the mould, especially where there is no iron loop to help, a small tough stick may be inserted into the loose cord and twisted until the cord is tight—then the other end of this stick should be tied back to the cord with a piece of thin, strong string. Whatever means of tightening the cord are used, the moulds must be held together without any possibility of moving while casting. (Illus. 28.)

The join where the two moulds meet should be lightly covered with a very thin coat of plaster to prevent any leakage when the liquid plaster is poured into the moulds—this may be done with some clay if preferred, but clay is apt to become loose at awkward moments.

Some sculptors also place an occasional strip of scrim, dipped in plaster, across the joint of the moulds (in addition, of course, to the essential tight cords) but this should not be necessary with a head of the dimensions illustrated here.

It should be remembered that plaster is inclined to swell as it sets hard (it also becomes quite warm during the chemical action, as may be easily felt with the hand). As with the use of irons, tying the moulds very tightly together with cords should also help to prevent the moulds from swelling and opening, when they are filled with fresh plaster.

The whole, tied-up, mould should now be placed a little above the ground, so that the fresh plaster to be used in filling it may be poured back into the bowl when necessary. If possible, stand the mould on a box or low bench. Place it with the closed end downwards, upside down as it were; and preferably with some wall or other rigid background, against which to lean it occasionally.

In filling the mould the objective will be to make a hollow cast not much more than an inch thick all over, or even a little less if possible. Begin by mixing, carefully, a bowlful of plaster as before, and pour this into the open end of the mould, now held upright. Place the empty bowl on the ground beneath it. Take hold of the top of the mould with both hands and turn or shake it round rather vigorously, so that the mixture of plaster gets into all the crevices and recesses and air bubbles are dispelled. As this rotary operation is continued, gradually lower the end of the mould until it is nearly horizontal. This operation is called "rolling the mould". Then lower the mould still more, letting the liquid plaster run right out from it into the bowl placed beneath.

Repeat this whole operation at once, holding the mould upright again, open end up, and immediately pour the plaster back into it. The plaster will soon begin to thicken and the operation should be repeated until it does so, when it may be left in the mould. This can now be turned about more slowly in order to spread the inside coat of plaster as evenly as possible—but once it begins to set, it should be left in position where it is; it will be inclined to pull up the first coating if rolled about too much in this state. Then mix another bowlful of plaster, pour it into the mould and repeat as before.

If skilfully rolled, a very thin coating of plaster should soon cover the entire surface of the mould, including at least some portion of the lower neck. It is not necessary to worry too much about the coating of this more accessible part of the mould at this stage, though it will be as well to let something of this coating run down here and there, if possible to the base.

This procedure will have to be repeated and continued until the cast is about $\frac{3}{4}$ to 1 inch thick, all over. If you are a beginner you need not be too fussy about the exact thickness, but add further plaster to any part where you have any doubt as to its being thick enough. Keep in mind that a very thick cast is less strong, and of course heavier to move, than a thin one—also it uses more plaster.

If the head has been satisfactorily filled on this plan, and the neck surface has been covered to some extent all over, the thickness of the cast round the neck and the base may

perhaps be built up more easily with some slightly stiffer plaster, using a steel spatula to finish the surface of the inside hollow. A damp slat of wood used on edge, or a knife, or any other ruler run very swiftly across the top end of the open mould and cast, just before the plaster has set, will level the base of the cast so that it will stand flatly and evenly when freed from the mould.

If the cast is to be a thin one, some strips or rectangles of scrim soaked in plaster and then spread out and flattened on to the inside of the cast will form a strong reinforcement, particularly to the neck, but do not put this on until the cast is well over a $\frac{1}{4}$ inch thick. If it is placed too near the surface when filling the mould the scrim can make itself felt unpleasantly on the outside face, and it cannot then be got rid of. Add a coat of plaster over the scrim, of course, inside.

There is one other way of filling the mould which some prefer, either because of the weight to be manipulated when the whole mould has to be "rolled", or where the moulds are too large for easy handling.

This other method is to fill each half of the mould separately, and then, when they are put together and tied as before, to run liquid plaster into the combined mould down each side, guiding this plaster into position by rocking and moving the mould, so that the gap between the thicknesses of plaster already coating nearly the whole surface of each half of the mould, will be filled in and well covered right round the head. The cast within the mould will now form one continuous piece as in the previous method of filling.

If this method of filling should be attempted, a very soft, wet sponge must be constantly used while filling each piece of mould, in order to clean up the edges where the fence has impressed itself. If the slightest amount of plaster splashing or overflowing from the filling is left on this edge to harden it will, of course, prevent the moulds from joining together properly.

Once the mould has been filled, it should be left standing for at least an hour to let the plaster set properly—the open end, of course, should be uppermost.

When the plaster has had good time to set thoroughly, place some folded sacking or other soft material on top of the modelling stand and put the filled mould on to it, base downwards. The folded sacking will help to soften any jarring when chipping out the cast.

To carry out this process of chipping away the plaster mould, a very blunt chisel—preferably with its edge rounded on a grindstone—and a light mallet, if possible made of wood, should be used.

In removing the moulds from the cast, first cut out and take off the cords. Then free and remove all the irons by chipping away the plaster around them wherever they have been embedded. Next, chip away the outer coats of white plaster, starting somewhere

near the top of the head. Do this slowly and carefully holding the chisel nearly at right angles to the surface, giving it sharp, light taps with the mallet. Chip away small pieces and do not on any account attempt to remove the plaster in large lumps. (Illus. 29.)

When a certain amount of the white outer coat has been chipped away around the top of the head, it may be as well to clear away the white plaster down to the coloured, first coating. This should be done if possible at some place where there is a large uncomplicated surface of the cast underneath, such as the top of the forehead. This will help you to find your bearings and will indicate that the surface of the actual cast has nearly been reached. The first coat of plaster to be put on the clay model was a coloured one, for precisely this purpose.

Once a fairly large patch of the coloured plaster has been disclosed, it will be a simple matter, altogether, to continue to remove the white outer coat. This will come away particularly easily wherever the coloured coat was daubed with the clay water. It is safest, of course, to chip away the outer coats of plaster right round the head first, leaving only the inner coloured coat to be very carefully removed at the last.

None the less, it is advisable to leave some of the solid plaster forming the mould around the base, or in whatever places it is supporting any overhang of the cast, until almost all the part above is free. Then this too can be carefully "nibbled" away by steadily chipping it off in small pieces, thus leaving the maximum support for the cast from the mould beneath, while always chipping away the heavy plaster above, first. (Illus. 30, 31.)

Some of the last remnants of the thin coloured coating will probably cling to deep undercuts—in the mouth, eyes, ears and under the nose, etc. These can often best be cleared by using one of the pointed ends of the small steel tools. (Illus. 32.)

Chipping out the cast is usually a most pleasurable occupation, with some of the excitement of discovery and surprise, as the dazzling white cast emerges—a replica of the clay model in a hard material. It is none the less very advisable to go slowly and carefully, as any attempt to remove the mould in large lumps will probably end by pulling away, with one of the lumps, some important or delicate part of the cast such as an eyelid, ear or nostril.

It is unlikely that the cast will emerge without some very minor damage, such as an occasional mark where the chisel has cut through to the surface of the cast unexpectedly. Such small indentations or cuts can be remedied easily, with the help of one of the small steel tools and some "killed" plaster—"killed", because if used as mixed normally, it would set harder than the plaster surrounding it and it would also, probably, be a different and slightly dirty colour.

The simplest way to kill the plaster for this purpose is to leave it until it is almost set

and then mix it up again with a little more water. Another way is to put some plaster in a spoon, just cover it with water and leave it thus, for some few minutes, before stirring it up again. In neither case, of course, must the plaster be allowed to become quite set before mixing it up again.

The surface of the plaster which is to be repaired should be thoroughly wet with a brush before the new "killed" plaster is applied. The small steel spatula, or whatever tool is used to smooth the plaster (filling the indentation, level with the original surface), should be dipped in water as it is being worked. The repair should be done as speedily as possible because the surrounding plaster will be inclined to absorb the water from the new plaster, immediately; it will quickly become almost like powder and will not be malleable unless water is dripped from the wet tool to keep it moist.

Forms can sometimes be built up by using a brush with liquid plaster—but always the plaster ground on which it is to be applied must be made thoroughly wet first, to hold the new plaster firmly to it.

To replace a piece broken off, of course, the plaster must be freshly mixed in the ordinary way, and both surfaces to be mended should be thoroughly soaked with water to prevent the moisture from the new plaster being absorbed before it is applied to the broken surfaces. It is sometimes possible to make small cavities in both pieces on the broken surfaces to be joined together, always being careful to leave enough of the original surface around the edges of the break, to ensure a perfect refit. These cavities can then both be filled with freshly mixed plaster—a little more than will fill them level—after both surfaces have been thoroughly soaked with water. The two sides of the break can then be squeezed tightly together. They must be held in position and should not be allowed to move until the new plaster in the cavities on both pieces of the break has set. This should form a strong tie.

Sometimes, short pieces of stout, rustless wire, wood or other supports can be inserted into and across both hollows and these ties will help to form an even stronger piece of surgery, when the plaster has set hard.

Once the fresh plaster has been mixed and is beginning to thicken, these operations should be carried out very speedily, so that the chemical action of the setting plaster is in no way impeded—the new plaster forming the tie should be as strong as possible.

THE FIGURE *chapter 7*

With the human figure as subject-matter for sculpture, further problems as to sculptural purpose and direction emerge, and technical procedure becomes somewhat more complex, but at the same time the interest and scope of the subject can become very considerably wider.

The human figure itself, of course, may differ in certain respects with different races and at different periods. These differences reside for the most part in proportion, texture of hair, face and colour.

Here we are concerned, rather, with the meaning which the shape of the human figure as an image can have on the human mind. In spite of the fact that the basic structure of the actual human figure remains fairly constant, the significance of its shape, used as a plastic symbol, can vary enormously in different societies.

From the sensuous rotundities of the early pre-historic Willendorf Venus and the like, where the sculptural image of the human figure was probably used to stimulate the imagination towards fertility (when the feelings of the primitive sculptor, that is, were exteriorized from his perceptive observation of the female form as a desirable pro-creative object, into the making of sculpture that was used for the purpose of suggestive magic), one may track the idea of the human figure in its changing shape throughout the vast history of sculpture down to the present day.

At different times it has been simplified or distorted, emphasized in its form and action, as also in its anatomical structure. Sometimes it has been naturalistic in its proportion and conception and used thus as a symbol for mens' desires; sometimes it has been idealized in sculpture as a thing of almost abstract beauty for pure aesthetic contemplation; again, it has sometimes been formed as a symbol of the image of a God or of Gods in the minds of men. Here the idea of God has often been conceived in form as a human figure of commanding physical or spiritual presence; this by reason of some instinctive understanding of the essential relationship which the inner spirit of life has with its outward form.

The contemporary student should, of course, take more than a casual glance at the various styles of past sculpture. This will also help him to study his own instinctive

reactions to the attitudes of mind of the sculptors of different periods, as expressed in their works.

He may care to regard the sculptures of Greece and the Renaissance as the high spots of the humanistic spirit, when man and the physical body of man, whether in its more idealized or more realistic shape, was the summit of sculptural beauty as imaged in his mind. Or he may prefer the austere sculpture of Egypt, for instance, where the dignified, still forms of the human figure give a sense of clear, simple permanence with a decorative beauty all their own; or again, the sculptures of India, where the human body, used prolifically in simplified conventions, provides a fecund rhythm of almost vegetative continuity, allied—as it was in Egypt—most often, to an architecture equally expressive of its own particular society and civilization.

With Byzantium and the Gothic, the religious atmosphere changes yet again the sculptors' view of the human figure, while in the near contemporary world the figure becomes primarily the vehicle for a more individual conception of the human personality, with all its emotional stresses and conflicts conveyed by the emphasis of rugged and romantic forms as used typically, for instance, by Rodin at its most intense and expressive phase.

Then, in reaction from the romantic idea and with the desire to find and express a more secure world within, the sculptor of the human shape, beginning first perhaps with Maillol, seeks for more stable forms in which to express himself. Forms are taken by sculptors at this period from a more simple, earlier, classical Greek world and also from any and almost every civilization, Africa and China included, which will usefully give inspiration to the conception of a more universal and generalized rhythm, within which to express the thrust of the force of life, and in which to gain release from growing tensions.

This main trend is later developed by such sculptors as Henry Moore in England, in whose works the monumental figure becomes for the most part, ever increasingly, a generalized re-assembly of the forms of the human body into an equivalent organization, in terms of the material used. But here also, there is the immense influence of Picasso, whose own desire for an extreme monumental expansion of the classical figure is expressed in a whole series of great compositions—single figures, double figures and mother and child studies.

Later, Picasso changes from this serene generalization into a vast series of savage attacks upon the human figure as an integrated organic shape. Limbs are dismembered, distorted and misplaced ruthlessly; faith in the natural order of growth gives way to disbelief and satire—none the less, the intense vitality of this all-pervading artist still comes through unmistakably and relentlessly.

In the contemporary world itself, which has for the moment fragmented into com-

batative elements, science takes the lead in thought, breaking up the physical elements and adventuring ever further into space. This activity finds its counterpart in the arts, so that sculpture in the contemporary world, in perhaps its most representative—but not necessarily its best—phase, rejects integrated natural appearance almost entirely.

Highly ingenious and, also, sometimes more or less accidental, collections of metal or other materials give, or attempt to give, closer expression to feelings aroused by the typically insecure, yet questing spirit of the contemporary world—a spirit in which the exploration and control of space plays so great a part and which is, of course, closely allied with forces of scientific destruction on an immense scale.

It is outside the business of this book to evaluate these matters critically or to attempt to record them; but it is none the less important to indicate these trends in a general way, to any student intending to make sculpture at the present time. For the question which has to be put is whether the human figure, in recognizable form, remains, as it has done over the past ages, the proper subject-matter for sculpture at all, not to say its most important subject-matter.

Although the attempt to find an equivalent set of entirely new forms or objects which will release the emotional tensions set up by science (forms which will express, that is, the feelings produced in sensitive, creative men by the intellectual trends and instinctive strivings of the spirit of the age), certain considerations should never be forgotten by the student of sculpture when he attempts to find the answer to this all important question of the significance of the human figure as a sculptural motive.

The human figure may be seen and approached in an enormous variety of ways. It may be seen synthetically as an anatomical structure of almost infinite complexity, wherein the force of life gives homogenity to a characteristic shape of the very greatest subtlety. This shape, moreover, is always mobile to a greater or lesser degree, so that the relationship of its parts are constantly changing with every movement; this, within the range of a vital pattern which can never be grasped in its entirety without an almost intuitive awareness of the whole design, as well as a knowledge of the physical structures which comprise its shape. And here, as a sculptural image, it may also become a vehicle of direct expression through sympathetic feeling; for we have natural understanding of the emotional significance of forms which present back to us the actions of our own living shapes with all their tensions and relaxations. Michelangelo and Rodin would be the notable exemplars here.

Or again, the human figure may be seen as an arrangement of simple forms and masses which will none the less give out, for similar suggestive reasons, the feelings which have been put into it by the sculptor, with a simplified proportion and rhythm playing their, perhaps, more direct, aesthetic part. In this form it can give out also, a greater sense

of security when contemplated, because of its more generalized and easily graspable organization.

These extremes of outlook may merge or be extended to almost any extent according to the temperament and outlook of the sculptor and they offer a vast range of plastic—or glyptic—expression. They offer at once an immense field for either direct humanistic expression or aesthetic expression—in so far as these two modes of approach may seem to differ.

Or yet again, the forms of the figure may be used as a motif only, a point of departure for an almost unlimited variety of formal expression in using the suggestive shapes made by the figure as it varies in attitude and proportion, and also, of course, in making use of the changing spaces which surround it.

It is doubtful whether any other forms, abstract or near abstract or any technical adventures with metal, wire and the like, interesting though they may be as invention or craftsmanship, will ever give to the sculptor such immediate and primary contact with life itself as study of the human figure—except in so far as such inventive constructions approach some suggestive aspect of the actual human figure, either unconsciously or by intent.

But one thing should be finally stressed; in all cases, whether the student gets his sculptural idea directly from the living figure (by using the living model to work from, selectively) or by designing his sculpture from a generalized idea of the figure, based on a fusion of memory and knowledge, he must have a definite conception of his figure as a sculptural idea or form—a complete conception in the round, towards the realization of which he will direct all his sculptural activity.

A life-study itself, can become a genuine piece of creative sculpture, provided the sculptor can grasp the complex forms of a particular figure as a whole unit, wherein the relationship of the parts to the whole has been understood, the rhythm stressed, and the figure realized as an integrated shape in the round—one which will express the sculptor's feeling of contact with living matter and act as a symbol for his appreciation of its wilful design.

Here, where the demonstration of a method of doing is the prime consideration, the approach to the figure will be similar to the one used earlier in making a head, that is to say a formal one. For the purpose of demonstration, the figure to be made and illustrated here will be a somewhat simplified and decorative one, representational in general outlook.

Exercises

Following earlier exercises in the making of simple, geometric constructive forms in

clay, it will be remembered that the basic form of a head was made by the simple expedient of joining a clay ovoid shape to the top plane of an upright and slightly tapering cylinder (see illus. 4).

In making a first exercise upon the standing figure theme, even though it is only intended to be a few inches in height, it will soon be found that owing to difficulties of balance (and unlike the miniature ovoid and cylinder form of the head), an upright figure in the round will not stand erect without the help of some rigid support.

None the less, it will be possible to follow a similar line of simple constructive thought by carrying out, on a board, some exercises in the conjunction of the basic forms which make up the figure, such as that shown in the accompanying illustration (see illus. 33).

Here, the figure has, for the most part, been reduced to cylindrical, or tapering near-cylindrical forms, with the head as before, being represented by an ovoid, and the shoulders and chest treated as one very simple form.

By a slight pressure on the board, the separate cylinders and parts of this figure may be a little flattened by pressure on to their under side, so that they will remain in position wherever placed; great variety of attitudes may be suggested with a little ingenuity and rearrangement of the parts when reassembling the figure in other attitudes. This exercise should assist the student to visualize the basic shape of a figure in the round, with some sense of the relationship of the geometric volumes arranged in a very simplified way.

A centre line through the torso has been indicated to denote the axis of the figure, so that note may be taken of the radiation of the horizontal lines of the main masses, suggesting shoulders, waist and pelvis, as they relate to this central axis.

The board on which these figurines are made can with advantage be placed at an inclined slope, so that the upper part of the figure is considerably higher than the feet. This will assist in suggesting the shape of a freely standing upright statuette. The basic figure illustrated here stands exactly 9 inches high.

These figure constructions will have something of the appearance of "lay" figures, but in many ways this simplified approach is a more truly sculptural one—regarding sculpture as the ordered relation of masses—than through an anatomical approach, wherein the feeling for these important simplicities of basic, constructive volumes may all too easily be lost in following the sensuous attractions of purely surface movement.

The common, monumental power of nearly all the great traditional schools of sculpture, including those of Egypt, Africa, India and China depends largely upon the realization of the underlying simple basic architectural forms in their different stylistic characters, notwithstanding the added sensuous attractions which a thorough knowledge

of anatomy can give to later periods of sculpture, whether of Greece and Rome, the high Renaissance, or the pre-contemporary world.

None the less, as was said earlier with regard to the making of the "head", a working knowledge of anatomy, at least so far as the skeleton and the superficial muscular system goes, should give clear and almost indispensable understanding of the movement of the figure, both as regards fundamental structure and surface movement. A short list of books dealing with anatomy for artists is given at the end of this book and should be studied in conjunction with the making of any figure sculpture.

Brancusi the first modern originator of the extreme and very conscious simplification of form and the prime initiator of the near abstract, "equivalent", aesthetic form, in place of natural representational form in sculpture, made his now famous comment on the work of Michelangelo by calling it "bif-tek", plucking the flesh of his wrist the while, to illustrate this remark. He would no doubt have included all sculpture built on the scheme of natural form in this comment.

But in spite of Brancusi's great significance and wide contemporary influence, it seems more than possible that, in giving this theoretical support to his own work and ideas, he shut his eyes deliberately to the nobility and strength of spirit expressed so clearly by Michelangelo in his use of the human figure, based on the scheme of nature—a scheme still closely associated with "sculpture" in the world's imagery.

Another almost indispensable activity which should accompany figure sculpture is to make drawings from the living model. Here the student may be referred back to earlier remarks under the heading of "Drawing", made in the first part of this book. If possible he should join some life-class in a School of Art; for few students are lucky enough to be able to afford the services of a living model for their own private study. Quite a lot, however, can be learned by studying the shape, and above all the structure, of one's own body in the mirror—where the modification and disposition of its forms may be observed at leisure with close attention as it changes position.

The human body should be looked upon as a source and fund of living form from which to extract expressive sculptural shape, rather than something to be copied and reproduced exactly. The varieties of formal theme which it can inspire are almost unlimited, both by reason of its enormous capacity to change its shape when in action, and its differences in proportion as in the divers relationships of its infinitely subtle parts. These may be simplified or detailed to almost any degree of complexity, according to the desire or need of the sculptor in presenting an expressive image of his sculptural idea.

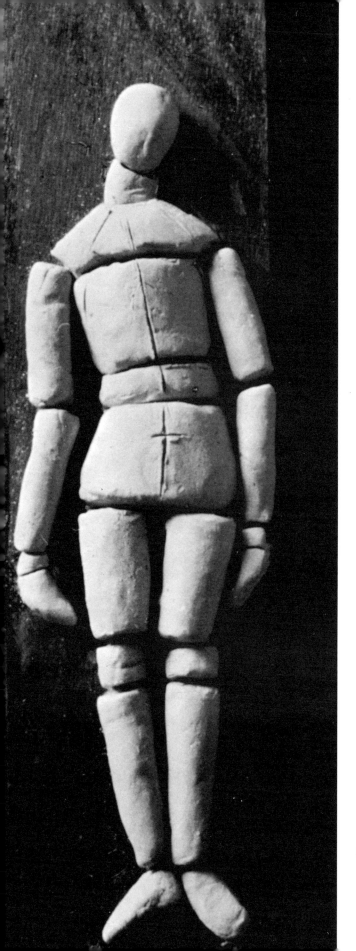

33. Exercise in basic shapes.

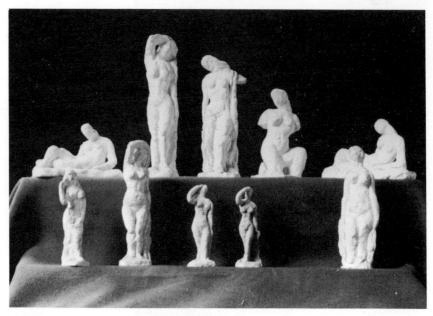

34. Miniature sketch models, clay and plaster.

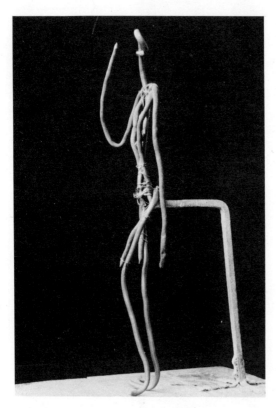

35. Armature. Side view.

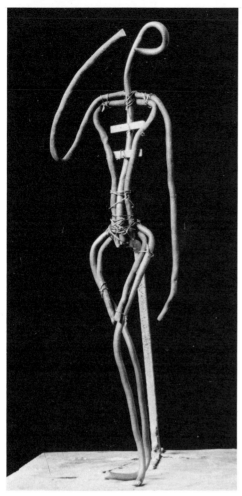

36. Armature. Front view.

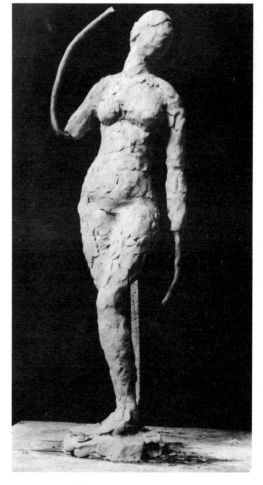

37. Front view. Covering the armature with clay.

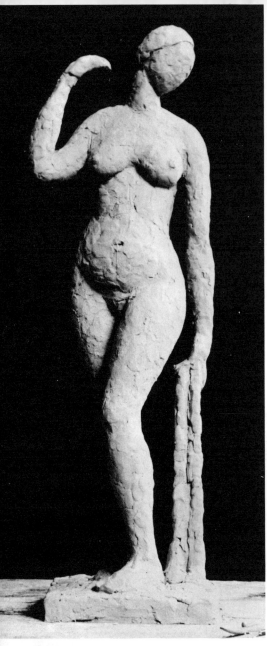

38. Front view. Intermediate stage.

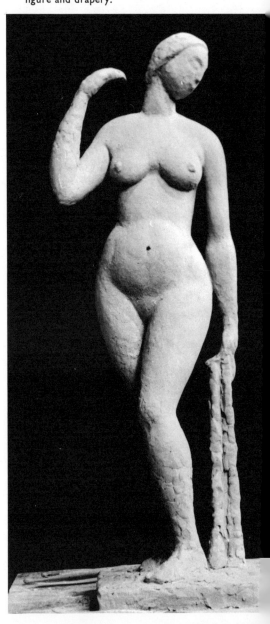

39. Front view. Armature completed. Clay covering figure and drapery.

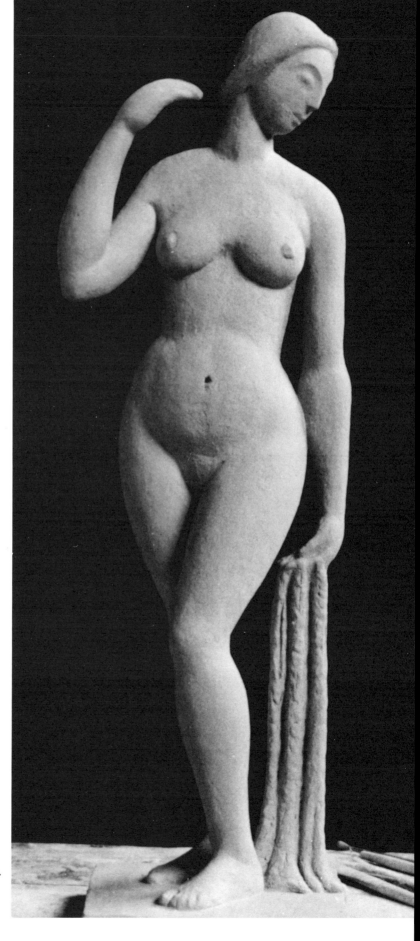

0. Front view. Final state. Clay.

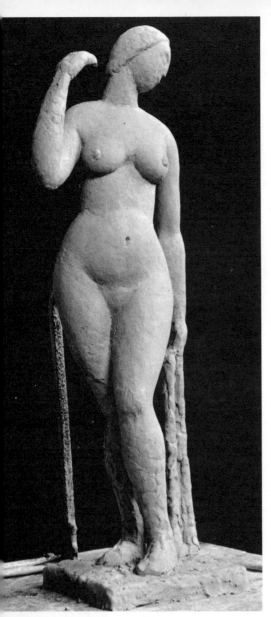

41. Three-quarter front view.
Modelling developed.

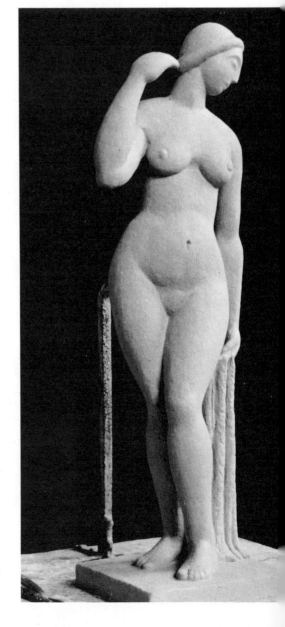

42. Three-quarter front view.
Final state.

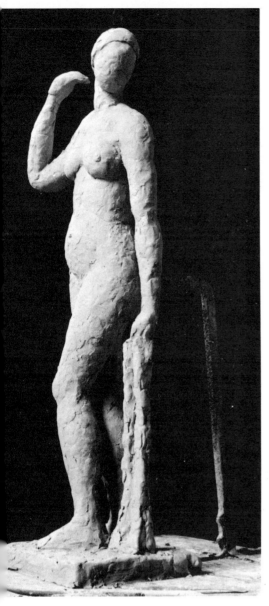

43. Side view. Figure and drapery set up in clay over armature.

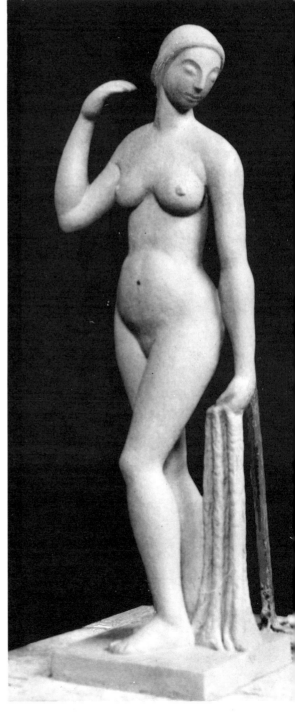

44. Side - three - quarter view. Final state. Clay.

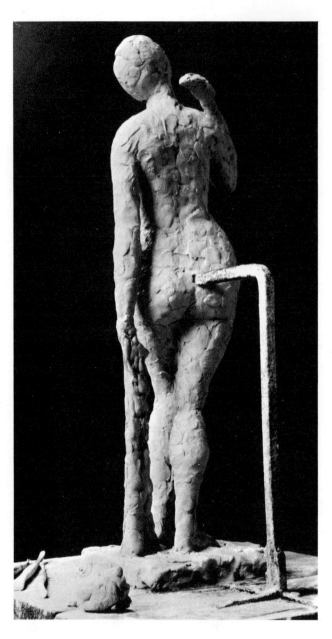

45. Back view. Armature cut. Figure and drapery set up in clay.

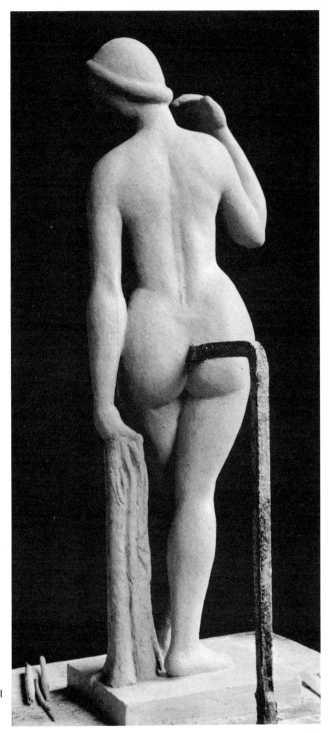

46. Back view. Clay. Final
state.

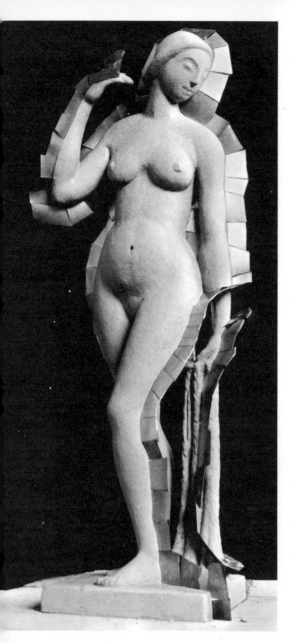

47. Fixing the brass fence to divide the moulds. Front view.

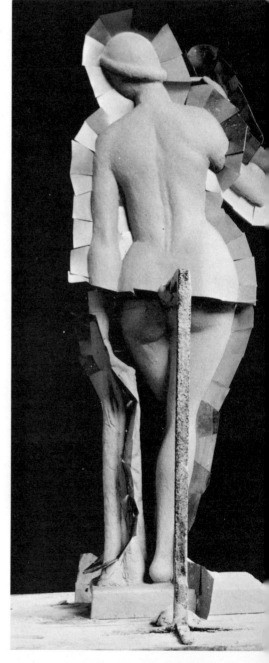

48. Fixing the brass fence to divide the moulds. Back view.

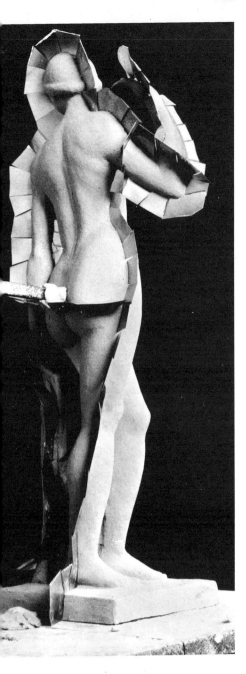

49. Fixing the brass fence to divide the moulds. View showing raised arm.

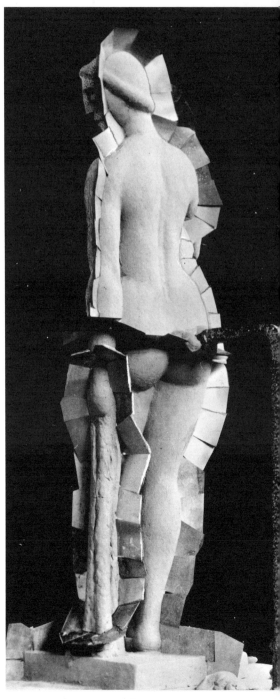

50. Fixing the brass fence to divide the moulds. Three-quarter back view showing division for lid on drapery.

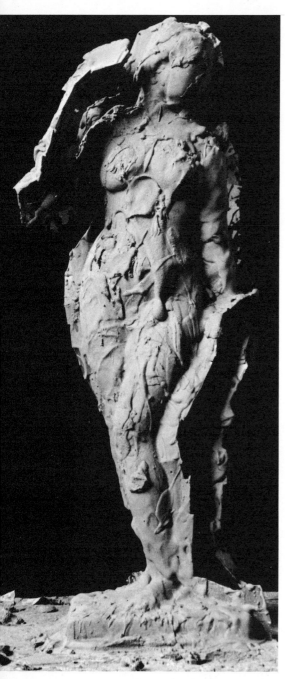

51. The first coat of coloured
plaster covering clay model.

52. The completed mould reinforced
with irons and wood.

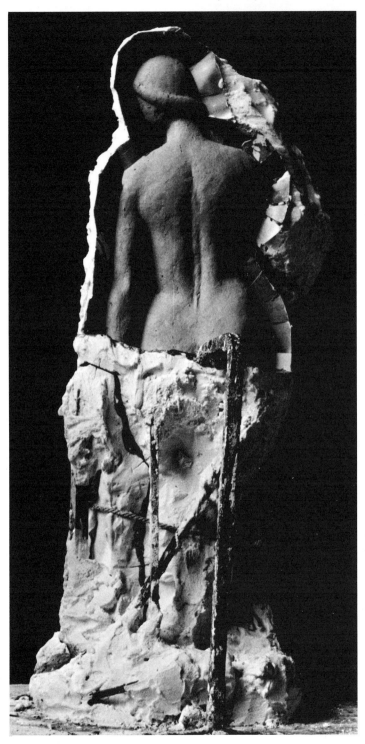

53. The mould opened. Top back
 section removed.

54. The mould opened. Section above raised arm
removed and lower section of back mould
opened.

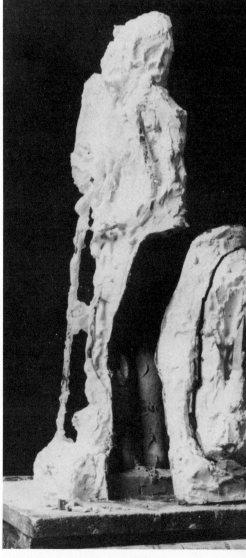

55. The mould opened. Lower back section,
with lid section for drapery in it, moved
away from front mould.

56. Removing the clay from the front mould.

57. The six pieces of the mould
with the clay removed.

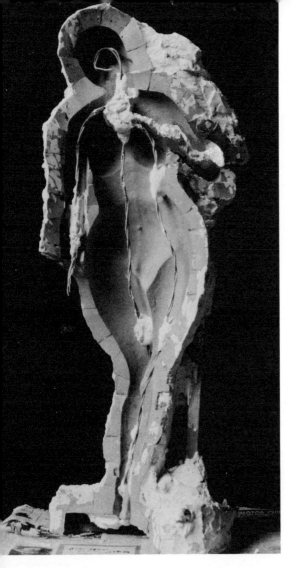

58. Reinforcing wires fixed in front mould. Section above raised forearm replaced and forearm filled in.

59. Filling the mould. Upper back sections refixed on front mould and filled in.

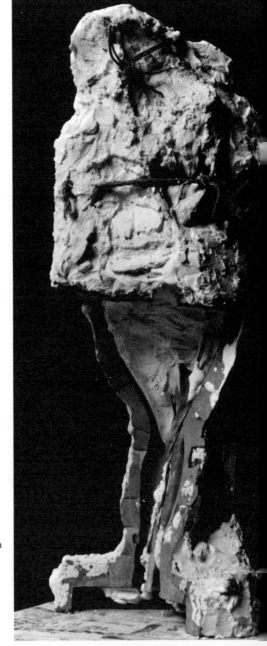

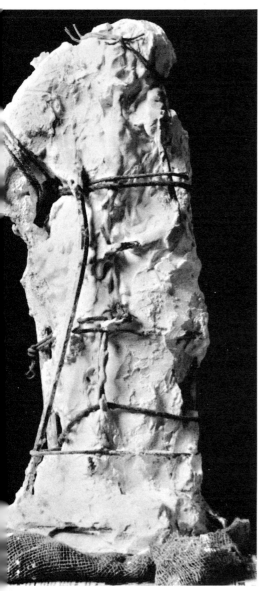

60. Complete mould refitted together and tied up for final filling.

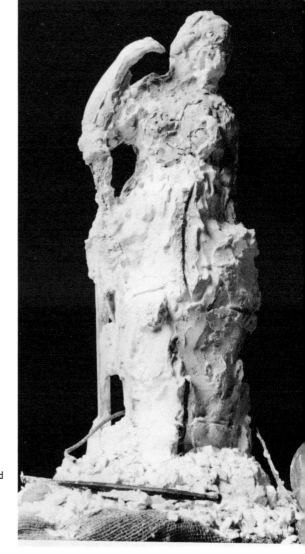

61. Chipping out the cast. The first irons removed and upper part of mould chipped away.

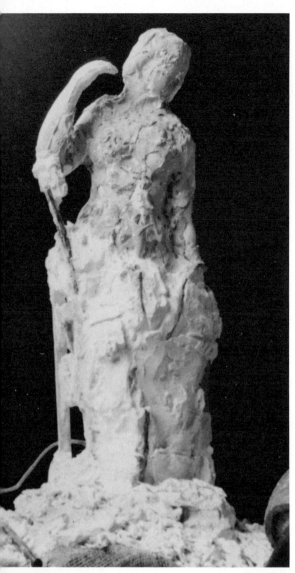

62. Chipping out the cast. The first irons and upper part of mould removed, showing coloured coat beneath.

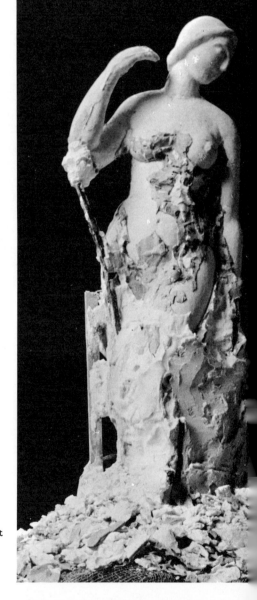

63. Chipping out the cast. Iron left until last to support the raised arm; wood still in place.

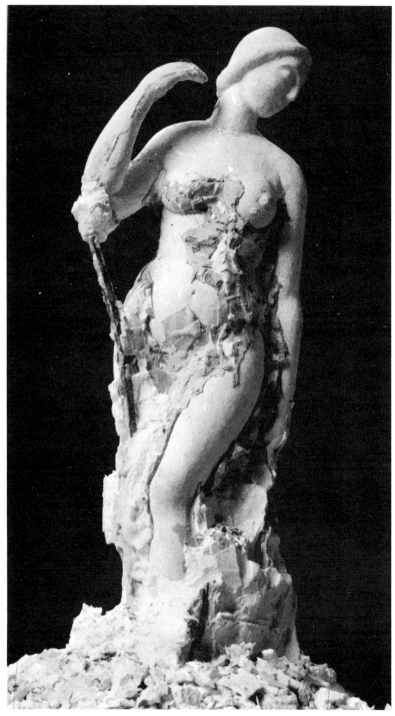

64. Iron, under raised elbow, left in place to support
arm. Wood removed.

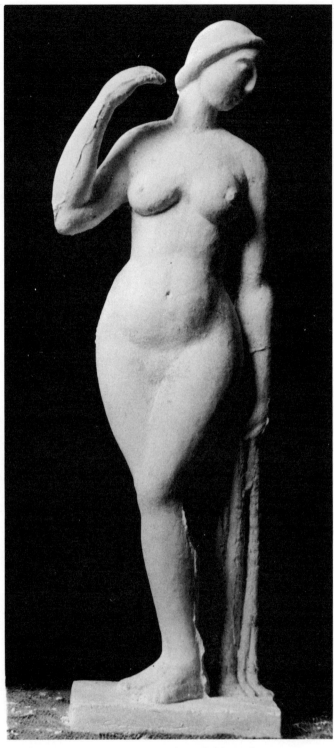

65. The cast freed, showing seam where divisions of
mould have been made.

THE FIGURE - ARMATURE *chapter 8*

The standing figure illustrated here measures just 2 feet in height and the first problem involved will be the making of an armature to support the clay figure with firmness. It must also have sufficient pliability to allow for some movement in arranging the attitude of the figure, particularly as regards the limbs, and especially when the work is being set up at the beginning.

The general principle to be followed in making an armature for a more or less upright figure in clay, is to make a solid, rigid support (which should interfere as little as possible with the clay figure being built up), to which can be attached a slightly more mobile framework on which the clay figure itself can be modelled.

This latter part of the armature, upon which the clay figure will be built, may, in idea, be likened to the bones of the figure—and indeed, in this sense an armature can be quite expressive of the movement and proportion, and also suggestive as to the general action, of the figure to be built upon it (see illus. 35, 36).

First, then, the main rigid support, an iron upright, firmly fixed to a base-board and with its top end bent to form a more or less horizontal arm, is usually made to enter the clay model at the lower part of the back. There is however, once again, no absolute rule here and in certain poses it is more serviceable to let the iron enter at the side of the clay figure. Roughly, it usually gives the best balance in holding a standing figure upright when it enters the back of the clay model a little above half the height of the figure.

The iron forming the support for a figure of these dimensions can be $\frac{1}{2}$ inch square in section and the lower end can be split into three or four flanges projecting at a right-angle to the sides of the iron, with two or three holes drilled in each branch through which they can be firmly screwed to the wooden base-board on which the clay figure will stand.

Sometimes, alternatively, this iron can be welded on to a flat semi-circular strip of iron, or one shaped like a horseshoe, with holes pierced through it to take the screws which will attach it to the base-board. (The base-board, to which the iron illustrated, and in diagram, has been fixed, measures 18 inches square—a larger board than that used for the head, because this size board will leave more room for the plaster moulds

surrounding the figure to rest upon, when the figure is being cast later.)

In whatever way this upright iron is to be fixed to the base-board it must be absolutely firm, as the whole weight of the armature and clay figure will rest upon it. In the case of a life-size or near life-size figure, where the iron itself may have to be increased in section to as much as an inch, flat, right-angled inverted iron brackets may be attached to its lower end at each side and then screwed down to the wooden base. An iron smith will best make such a support if requirements and measurements are clearly stated.

For the 2 foot high figure being illustrated here, the iron support was bent at right angles horizontally and vertically, as shown in the accompanying diagram on which the measurements used are indicated. It is well not to get the horizontal measure too short or the upright itself may get in the way when modelling the back of the figure; also it may make it more difficult to remove the lower back mould from the clay model when casting, without unscrewing the irons. If it is made too long, on the other hand, the weight of the clay figure and armature which is attached to it will be inclined to sway it while working (for protecting iron from damp, see page 82).

Keeping these considerations in mind, an iron support may be made proportionately to suit a figure of any design or size and, of course, it may be made out of either square or round sectioned iron, provided always that it is strong enough to support the weight of clay to be used in the figure, without swaying or exerting downward pressure on the horizontal arm.

If desired, the top, short, upright end of the iron, to which the armature will be attached, may be made to lean at an angle, backwards—or forward—if the pose of the figure seems to require this.

Adjustable iron supports can also be obtained ready made for various heights and for differing actions of the body.

The figure armature itself (see illus. 35, 36), was made from $\frac{3}{8}$ inch wide composition piping bound together and then to the top upright of the iron, with copper wire. As it was desired to leave some play for improvisation in setting up this figure, the general pose was established, but the ends of the piping to support the arms and legs were left longer than required, so that they could be cut down later when the figure was set up in clay. The loop forming the support for the head was, similarly, left longer so that it could easily be diminished, extended or altered in position as required.

The elbow angle of the piping for the raised arm was left a very open curved one at this stage also, for once the piping has been bent

IRON SUPPORT

to an acute angle, any attempt to alter the length of the upper arm, by making a new angle at a higher or lower place in the piping, would be likely to weaken it, so that it would probably not be able to maintain the weight of the arm in the desired position. With a model of this size, where the ⅜ inch piping will take up an appreciable section of the arm, the piping will have to run very near to the centre of the clay if it is not to protrude in unwanted places.

Indeed, as the width of the piping to be used for any larger figure would have to be increased proportionately, this consideration—that the piping should travel as near to the centre of the clay as possible, particularly at wrists and ankles (the narrowest parts of the figure)—will always have to be borne in mind.

In modelling a figure from life, of course (or enlarging from a small scale model or even from a drawing), or wherever the exactitudes are to be fixed beforehand, it is always as well to take a few measurements with the calipers, from shoulder to elbow and so on, down the bony structure of the frame. This is particularly useful in fixing the length of the limbs, and to ensure that the lengths of piping forming the armature will fit into the centre of the narrow parts of the clay figure which is being set up.

Any proportional errors here can make great difficulties when building upon the armature later, especially where the acute-angle bend of a joint has to support any weight of clay along its length. If there is real trouble in this respect, once the clay model has been set up, there will be no help for it but to replace with a whole new piece of piping in the armature. Otherwise it will be necessary to erect some sort of rigid prop from the base upwards—a long lath of wood for instance, may have to be fixed from the wooden base upwards, reaching underneath the elbow to support the upraised arm from below should the angle have been so weakened that it has lost its power to hold the clay limb in position unaided.

It will be seen from the illustration that two small pieces of wooden lath have been inserted into the armature on which the torso will be built—these will give support to the main mass of the clay and help to prevent it from slipping down the smooth piping. In a larger figure, strips of wooden lath can be wired along the length of the piping wherever a considerable quantity of clay is to be built—for instance on the thighs. Wooden butterflies may be suspended from the shoulder piping by lengths of rustless wire (to help support the mass of clay comprising the torso) in the same manner in which they were used when setting up the head; and rustless wire may be wound round the piping supporting the limbs to prevent the clay from slipping down this part of the armature, if desired.

For the small scale figure shown here the simple sort of armature illustrated will usually be found to give quite sufficient support to the clay. The whole armature should

be attached firmly to the iron by binding it with rustless wire to the upper vertical bend. This will, none the less, allow some freedom or swing of movement, if required, during the setting up of the figure in clay.

Insulating tape, normally used by electricians, can sometimes be very useful here also; if desired, it will cover any binding wires, etc., fitting quite tightly, and it will assist in binding it generally to the iron. The clay will adhere to it very well indeed.

Modelling the Figure

The statuette illustrated here originated in a very slight compositional sketch in pencil which materialized the image of a female figure, somewhat decorative or monumental as may be thought—one of many shapes based on the human figure which customarily dwell in the sculptor's mind. These images, awaiting materialization, are probably the residue of impressions left over from observation of the human figure, constantly noted while making drawings from life, and also from residual impressions of a stream of sculpture, primitive and classical, enjoyed over many years and absorbed by the memory.

Once the idea has materialized in suggestion of shape, even so far as the slight pencil sketch shown here, a very small rough sketch model may be made in clay. But if such a free sketch, in the round, is to stand erect without the use of an armature it will have to stand only 3 or 4 inches in height, and even then parts may have to be thickened considerably or else clay supports of some sort will have to be attached.

None the less, miniature sketch-models of this sort, executed very rapidly, may be extraordinarily suggestive and useful for development on a larger scale. Such small models, of course, may themselves be constructed with a small armature to keep them erect if standing upright.

NOTE FOR FIGURE

When recumbent, such models may be made just as easily, of course, on a somewhat larger scale without an armature, if so desired. But in fact, the very miniature scale suggested here is perhaps the best method of getting the idea speedily materialized in the round with the most complete freedom and unity.

Once this nucleus as it were, is created, it forms a tangible plastic idea around which

the sculptor's imagination and critical faculty may operate and develop. The illustration gives a view of a collection of these miniature sketch-models, some of which have been developed into larger sculptures. None of them measures more than a few inches in its largest dimension. (Illus. 34.)

The two centre (bottom row) tiny figurines in clay were the first suggestions in the round for the figure with drapery actually shown here, in different stages of development. They measure under 3 inches in height. None of the little models shown took more than half-an-hour to execute and the two centre models mentioned took up only a few minutes—yet they proved very useful in giving reality to the idea as a shape in the round, making it easier to envisage the figure in plan. To some extent, they resolved specu-lation as to how the shape of the whole figure would develop when seen from different angles, as well as from the viewpoint indicated in the first pencil sketch.

This information was also helpful in setting up the armature—for instance, in deciding the angle of projection of the raised arm from the body, and the position of the lowered arm in relation to the forward knee. A sketch model in the round immediately clarifies the projections, which will at once become more apparent to the mind in plan as well as in elevation.

The first illustration of the figure shows the front view of the armature loosely covered with clay, but the piping is still left bare on both the lower arms. (Illus. 37.)

Before the piping was cut to final length, two pieces of copper wire were bound to the lowered arm just above the position for the hand and left hanging downwards, vertically. The lower ends of these wires were inserted into the clay of the base, thus forming a support for the drapery. It was then covered loosely with clay and left to harden a little in the air.

These wires were the only support used for the drapery. It was made thus, both in order to leave complete freedom as it might suit the design in modelling the drapery later, and also so that it would be easy to cut through if it should become advisable to take out a section of this drapery later on. This would be done in order to simplify the plaster casting by moulding this section separately and rejoining it to the model in the plaster state—a course not actually resorted to in the event.

In making the very rough miniature sketch-model little regard was paid to exact proportion. Because the final figure in clay was itself only intended to measure 2 feet in height, it was thought better to leave this consideration to be decided in the final setting up of the figure itself.

The question of general proportion is, of course, nearly all important in sculpture. Indeed, it can be said that the proportion—the mathematical relationship of the parts of a sculpture—is one of the prime factors in characterizing the sort of impact which a figure

will make on the beholder at first glance and therefore of its essence.

The Greek sculptor Polycletus illustrated his famous "canon" — or general law of measure, governing the proportion of the so-called perfect human body—by a series of somewhat heavily built, but very impressive masculine figures in bronze which we can now judge only from existing marble copies of lost originals. These originals were lost, for the most part, because they were melted down in later times for the value of the bronze. The bronzes would first, of course, have been modelled in clay or wax. These figures were mathematically controlled in the proportional relationship of their parts to the last degree. This idea of a perfect plastic construction, based on the natural shape of the human figure and expressing its life by selective re-creation of its forms in the rhythmical order observed in nature, has typified figure sculpture—certainly the classical figure—almost down to the present day.

As to the plausibility of the attempt to find a perfect proportion which will satisfy some general sense of harmony within all mankind—the classical idea in sculpture—much has been written and many sculptures have been made in support of this idea, with greater or less success.

What is important is, that the sculptor should have the vision and exercise the will, to order all the forms he uses into one unity of shape, integrating all the minor rhythms and giving a central balance to the whole work. For this all-over pattern of growth will symbolize for the beholder the vital force which the sculptor has put into the work and it will express his idea beyond any of the technical contrivances used in the making.

Proportion, then, meaning the relationship in size of the parts to themselves and to the whole—head, torso, arms, legs and so on, down to the smallest details, is of prime importance in expression. For those interested in the conscious attitude of mind among the great masters, the works written or illustrated graphically or plastically, of Polycletus, Dürer, Leonardo, for example, may be referred to. For the opinion of sculptors that mathematical or geometric proportion is at the base of sculptural thought, Rodin, Maillol, Brancusi and a host of others could be quoted.

This is but to say that the ordering of the volumes and the pattern which the parts of the body make with the whole, is of prime importance in conceiving the figure as a piece of sculpture, no matter how much or how little anatomical detail or sensuous surface modelling are included in the final work. These latter are personal and quite legitimate qualities which can add most considerably to the attractions of the figure, but the main masses which form the design should be established as soon and as directly as possible.

Although the proportions of a generalized figure—the classical figure—may be of service when setting up the work, it should be observed that in more contemporary terms the general proportions are considered rather as an expressive (or even expressionist)

factor in the design seen as a whole shape. No strangeness of proportion need be avoided so long as it is generally apt to the feeling which it is desired to express and provided that it is integrated with the shape as a whole.

In the first illustration, the front view of the figure being made here (which shows the armature entirely covered with clay, with the exception of the arms), was built up very quickly, the clay being pressed tightly round the piping. Then the wires were attached to the lower arm reaching to the base, as mentioned earlier, and some slight indication of the formal drapery was developed. The armature supporting the lower arms was then cut to length and covered with clay. The second illustration of the front view shows this state. (Illus. 37, 39.)

The formalized drapery, in conjunction with the vertical of the lowered arm holding it, was intended to make, as it were, a supporting column contrasting with the movement of the upraised arm opposite, as well as helping to stabilize the changing planes of the whole figure as they swing round its axis. The illustrations of the three-quarter front views, in both complete and incomplete state, perhaps show this to best advantage (see Illus. 41, 42).

A point with reference to the base itself, should perhaps be mentioned here. The size of this will have to be proportionate to the figure standing upon it in the final work. But where there is any doubt as to the length of the lower limbs when setting up the figure, it will be as well to err on the side of allowing a greater height to the base than may seem necessary. This will always permit some lengthening of the legs by cutting down the top of the base—whereas it can be very awkward if it seems desirable to lengthen the figure and there is no space left beneath to allow for this. It is a simple matter, on the other hand to lessen the height of the base itself, from below, before casting, if this should have been left too high—a flat surround made of clay laid on the base-board will lessen the depth of the base in the mould, to any degree required.

The further progress of the figure in different stages of development can best be traced in the illustrations (37 to 46).

Once the first covering of clay has been pressed round the armature with the hands, the forms were built up, as in the making of the head described earlier, with small pellets of clay. These pellets were pressed into place and shaped on the model with a wooden spatula. The model was turned around constantly in the early stages and the photographic illustrations show the development of the figure as a whole composition, from the back and three-quarters views also, as it was built up. (Illus. 45, 43.)

Once the whole figure including the drapery had been developed into a stable composition by the addition of pellets of clay to the general volumes as it was rotated round and round, more attention was given to the separate individual forms. The

surfaces of the forms were more closed by the addition of smaller pellets of clay pressed right home and thus became inevitably firmer and more smooth.

By this process, keeping the forms used very simple and nearly geometric but in accord with the general anatomical scheme of the figure, a certain compactness of volume will develop naturally, and a clarity or geometry of structure can be picked up and developed to any extent desired. In a sense, the shape initially built will begin to suggest its own final development as the forms which comprise its mass become more closed and geometric, and more defined and related rhythmically—but this more final operation should not be commenced until the shape of the whole seems to have stability and balance from all viewpoints as regards the main masses.

As the volumes are expanded by the addition of further layers of clay they should seem to the sculptor to approach ever nearer to the all-over shape for which he was seeking in his original conception. This is the reverse of a carving conception in stone in which the stone will be cut down always, until the shape left is a disclosure, or a reduction down to the initial sculptural conception.

The intensity or clarity with which the plastic idea has been held will determine the final shape to which the model will grow—it should also give a certain rhythmical tension to all the outside surfaces of the clay model, as though they are an expansion to a maximum dimension impelled by a central force from within.

The actual surface finish desired and the amount and variety of detail to be included are, of course, largely matters of personal taste. These matters will also be modified by consideration of the final material for which the work is intended. If bronze or other metal is to be the final material, a more free, open and flowing design may be more apt than would be the case if the works were intended for terracotta or cement, for example. But bronze itself, permits of a variety of patinas wherein the finish and colour of the metal can be used with great differences of effect.

Here, we are concerned only as far as the transfer of the clay figure into the more permanent, but often intermediate, state of plaster. None the less, this statuette has been made with the idea of bronze for its final state. The texture of the formalized drapery has been left rougher than that of the figure to give some surface variety when it is put into this final material.

It may also be taken into consideration that the metal will take a high polish if desired and its nature in this respect, can add its own luminous mobility to the design of the figure, if it is of a slim and open character. This can legitimately be allowed for when imagining the design in the first instance.

WASTE-MOULDING
THE FIGURE
chapter 9

As with the casting of the head described earlier, the method of waste-moulding is the one most habitually used by sculptors to obtain a replica of the clay figure in plaster. In principle the process of moulding is the same as with the head, but it becomes more complicated in practice because more than two pieces will be required in making the moulds. Indeed, each figure to be cast will form an individual problem requiring a certain ingenuity of approach suited to the character of the particular work in hand. This can sometimes involve making the moulds in many pieces.

The simplest figure mould usually consists of three pieces. If the figure is dead upright and compact, a fence of metal or clay may be placed right up both sides of the figure and over the head and shoulders, on a line splitting the depth of the figure a little more than half way towards the back; so that the front mould will be in one major piece, as in the moulding of the head described earlier.

But because of the interruption by the upright angle-iron situated at the back, which supports the clay figure, the back mould will now have to be made in two pieces, divided by a horizontal fence on a level with the position where the iron enters the clay. This division will enable the back mould to be opened in two sections and thus avoid the iron.

It will also allow the mould to be filled in two operations if desirable. First, by replacing the top section of the back mould in position and tying it to the front mould, and then filling this upper part of the combined mould; next, by replacing the lower section of the back mould in position on to the front mould (where it will also, of course, fit against the lower edge of the top section, now fitted back in place). Then the filling of the whole mould may be completed.

All these matters should become more clear as the moulding and casting of the figure shown here is illustrated and described.

This somewhat more complicated figure—which has considerable rotatory movement; where the raised arm is projecting forward and the lowered one has drapery hanging down to the base—will involve some further considerations in planning the moulds. These considerations are, however, by no means unusual in figure casting, but they will call for more than the three pieces used in waste-

moulding the very simple figure just described.

In principle, and in spite of these complications, the moulding of this figure has been carried out on much the same plan as the life-sized head. That is to say, a large front mould was made—and reinforced—so that the other pieces of the completed mould might all fit securely on to it, enabling it to be filled properly. The whole operation, as will be seen, necessitated making the mould in six pieces. (Illus. 57.)

It was thought advisable to adopt a quite straightforward plan for demonstration here, though, in practice, it may often be possible to simplify a complicated figure by cutting away, cleanly, any complicated projections or subsidiary parts of the model, casting these pieces separately, and rejoining them carefully later on, when in the plaster state. In the present model for instance the raised arm could have been cut through below the shoulder, and then moulded and cast separately. It would have involved making a reinforced joint when replacing it on to the plaster figure.

Likewise, it would have been possible to mould and cast separately, a major section of the formal drapery (or even a section of the drapery including the hand and part of the lower arm above it which descends freely beside the body).

The removal of these pieces would have then reduced the rest of the figure to a shape which could have been moulded more simply in three pieces. But this would have involved refixing the separated parts, when cast in plaster, on to the main figure—a delicate operation, especially with a figure of this small size.

It was, therefore, decided to mould the figure exactly as it had been modelled and without cutting away any of the parts or casting them separately. As will be seen later, however, careful consideration was given to the arrangement of the fencing dividing up the raised arm, as also to the division of the lower drapery, so that the separate pieces of the mould would pull away from the clay model with ease; and also so that they could be fitted together very exactly, and in logical order, to allow the reassembled mould to be filled in a satisfactory way.

Brass shims of suitable proportion were first cut, as in casting the life-sized head—pieces from about $\frac{1}{2}$ inch to 2 inches in length and of such width that they would not project more than $\frac{1}{2}$ to $\frac{3}{4}$ inch when inserted into the clay.

The fence was first built (see illus. 47, 48, 49, 50) round the back of the head and around the shoulders and down some part of each upper arm, running on a line placed a little more than half way in depth from the front of the figure. A fence was also built down the outside of both legs, on a line situated, likewise, a little more than half way, backwards in depth, from the front. This line of fencing was then continued diagonally right across the base and down to the base-board.

The small aperture between the lowered arm and the torso was then filled by the

insertion of several small pieces of the brass sheeting cut to fit. Likewise, the open space between the lower legs was filled in with a brass fence. These pieces of fencing were carefully adjusted, and fixed into the clay with the help of a wooden spatula, using the support of a finger-tip on the other side.

The fencing on the side of the forward leg was then turned to join the fencing coming down the side of the lowered arm where this arm makes full contact with the thigh. This arrangement of the fence (the position of its line being situated rather more to the back than the front of the figure, all round), ensured that the front mould would cover nearly three-quarters of the head and torso and, in spite of the twist round of the plane of the legs, more than half of the legs, as well as of the feet and base, all in the one front piece.

The illustrations, both the ones of the clay model showing the brass fence projecting, and the ones showing the opened moulds, should be most carefully looked at in order to clarify this point.

It remained now to consider the upraised arm including the hand, and the lowered arm holding the drapery, and to find the best method of dividing these so that the pieces of the mould would pull away with ease and also fit together in sequence, so that the whole mould could be filled.

The first difficulty to be thought of, when filling the mould containing the raised arm and hand, would be to ensure beyond doubt that the liquid plaster would be able to fill right up to the finger tips—for it must be remembered that when filling the re-assembled mould intended to contain the body, the mould would be standing with the (base) end upwards for pouring. The head would be downwards on the ground. The liquid plaster would not be likely to run up to the bent elbow easily and then down the arm to the hand—especially as this arm is placed in a forward position relative to the body.

In order not to take any chances and in order to simplify the filling of this part, it was decided to divide the mould of the upraised arm into two sections.

First a fence was made round the top of the hand near and across the top of the finger tips. This was continued on a line running down the front side of this raised forearm nearly to the elbow, thence returning across the arm and up the other side to rejoin the line of fencing started on the top of the hand. (Illus. 47, 49.)

This fence was intended to make a pull-away piece of mould which would allow entry on the outside of the raised arm and hand, both to help remove the clay and, when replaced in position, to be filled first with the plaster forming the cast.

The fencing up the side of the torso beneath the raised arm was then continued round the underneath of the arm and elbow and up the back of the elbow, until it

reached the fencing for this pull-away section where it crosses the arm (see illus. 47, 48, 49).

It should be repeated here that the general principle, that the front mould should contain the main part of the figure being cast, was followed out. This fencing underneath the arm was kept well back all around the elbow, thus making the front portion of the mould contain the greater section of the upper arm.

It should also be noted that the angle which the fencing makes with the surface of the raised arm is such, that the outside section would come away very easily from the main mould.

It was then decided that if another division at the back of the upper arm, behind the shoulder were made, this new small section of the upper arm mould could easily be replaced after the filling of the raised forearm and hand. This would ensure that the whole of the raised arm from the shoulder could be emptied of clay from the back and also filled with plaster with absolute certainty before the filling of the rest of the figure was attempted.

Accordingly, a small fence was placed across the back of the arm behind the shoulder, thus making a small section of the mould to contain the back of the upper arm down to the raised elbow. (Illus. 48, 49.)

This shows clearly in the illustration of the model with the brass fencing around it from the back view, and again particularly clearly in the illustration showing the opened mould with the clay model still inside and the top section of the mould removed—in this illustration the brass shims across the arm have not yet been removed. (Illus. 53.)

Next, a horizontal fence was made right across the back and just touching the angle iron where it enters the clay figure. A small band of clay was first placed round the iron where the moulds would otherwise cover it. This clay band, being soft, will allow a little movement of the back moulds against the iron when first pulling them away from the model. (Illus. 49.)

It is the safest habit to make the horizontal fence just level with the lower edge of the iron so that the top back mould may be opened and then lifted upwards from the iron, while the lower back mould may be gently edged backwards and removed sideways from underneath it.

If there is any difficulty here, it is usually recommended that the iron be cut to ease the removal of the lower mould—in fact, this should rarely be necessary if the top of this lower section of the mould barely reaches the bottom surface of the iron. But, of course, the iron must be sacrificed without hesitation if there is a question of damaging the mould.

The other matter to be considered carefully once more, and as always, is the angle which the fence is to make with the surface of the model.

In the present work, when opening the mould from the clay, the upper half of the back mould will be the first piece to be pulled away from the figure. It will be pulled in a direction with some little inclination towards the right side (from the back view). Examination of the photographs of the opened mould from the back view should illustrate this twist most clearly and the edge of the opened front mould seen from the back view should indicate the angle at which the brass shims were inserted and the importance of considering this angle when fixing the fencing. (Illus. 53, 56.)

The final problem now remaining for consideration was the moulding of the bottom of the lowered arm and hand descending freely from the body beneath the fencing which crosses this arm, and the moulding of the drapery extending down from this hand to the base. (Illus. 47.)

It was decided here (somewhat as with the raised forearm) to make a pull-away section or door within the lower back mould so that access might be obtained to the hollow within it which would contain the drapery, hand and portion of the lower arm beneath the fence. Such an opening would enable the clay and armature to be freed from the hand and drapery, so that the removal of the lower back mould would be facilitated, and so that entry could be obtained to clean this part of the mould before filling from the base.

Accordingly, a closed fence (or division) was made on the drapery beginning above the base, running up the front side of the drapery and across round the back of the hand and wrist, continuing down the back of the drapery, thence circling forward across its outside edge above the base to rejoin the line of fencing where it started on the front of the drapery. (See illus. 47, 48, 50.)

The angle of the metal to the clay surface was so arranged that the section would pull away very easily. The line followed by the metal fencing was varied in direction, so that this section on the lower back mould would fit back into place and key into the exact position. It could be likened to a door or lid in the lower back mould, the opening of which would give access to the channel through this mould made by the lower arm, hand and drapery.

Once the all important matter of how the fencing is to be arranged, how the mould is to be divided, has been settled and the brasses have been finally inserted in position, the operation will continue as with the head.

First, a coating of the tinted plaster with some colouring in the water is to be applied all over the model—an illustration of the figure and fencing with this coloured first coating on it is given (see illus. 51). It should be remembered, as before, to make sure that this first coating is not too smooth. Close examination of the illustration will show the surface roughened here and there, additionally, by a few blobs of setting plaster

77

thrown strongly on to this surface, last thing.

(It should also be noted that if a clay fencing is to be used, out of some personal preference or because brass sheeting is for some reason not available, then the fencing for the front mould will have to be placed and supported first, while the rest of the figure is covered with soft paper, damped. This will only be removed—with the clay fencing—when the whole of the front mould has been completed. The edge of the mould will have to be trimmed and the rim of the mould which has been made by contact with the clay fencing, will require "keyhole" sinkings to be cut at intervals along its length; the whole of this return edge including the "keyholes" will have to be well brushed with clay water in order to prevent the back moulds sticking to it.

As each section of the mould is built up, this same process will have to be followed. The clay fence will have to be removed and "keyholes" made as before, while the rest of the mould is covered with paper until the final section has been made.)

This first coating must be well distributed by throwing the liquid plaster all over the figure. As in casting the head described earlier, wet plaster can best be placed where it is wanted on the clay figure, by dipping the finger tips, bent upwards, into the bowl of liquid plaster, with the back of the hand facing the model, and then moving the hand forward to throw or sprinkle it. Spread it over difficult surfaces and into all recesses, by blowing hard on the wet surfaces to distribute the plaster.

When set, this first coat of tinted plaster should be daubed here and there over the surface with clay water, as described earlier, so that the subsequent coats of plaster will fall away easily when chipping out the cast. These daubs, however, should be kept away from the position of the brass fencing, as cohesion in the thickness of the mould will be needed here.

Two further coatings of plaster without any colouring matter in it should then be applied all over.

The matter of reinforcing the moulds will now have to be considered.

If new irons can be purchased, cut, and bent to suit the shape of these particular moulds, vertical and transverse, well and good. In the casting illustrated here, irons already used many times were employed.

A long and fairly straight iron was placed, reaching from under the chin, running down in front of the body and forward leg to a position just above the foot. It was embedded at both ends and in the middle, where it made near contact with the mould.

An iron already bent at one end was made use of to reinforce the mould underneath

the arm and then right down, to the front, left-hand corner of the base—it shows very clearly on the illustration of the completed mould. (Illus. 52.)

Another piece of iron was used to reinforce the mould underneath the elbow and this iron, which bridged the gap between this part of the mould and the mould covering the front of the body, was strongly embedded both underneath the elbow and down the main part of the mould. This projecting piece of mould underneath the arm would not only be a likely weak spot, but when chipping out—as will be seen later—this iron would have to support the upraised arm without fracture, while the mould around it was being chipped away. Strong support would be indispensable in such a position.

A bent iron was used on the opposite side of the figure, running from the outside of the head near the chin. It made contact with the right shoulder, continuing down the front of the arm and turning inwards nearly horizontally, just before reaching the fence line dividing the lower back mould from the front mould. Thence it extended across the front of the torso making contact with the two centre upright irons which nearly touched each other here.

This iron was left partially uncovered down the arm and across the front, but it was embedded on to the mould at the shoulder, also at the angle just above the fence and at both ends.

One more iron bent nearly at a right-angle was run round the front of the mould covering the thin base and embedded in three or four places—it shows clearly in the illustration of the completed mould. (Illus. 52.)

These were the only irons used for the front mould. But as there was a considerable twist in the lower part of the front mould and the base projected a considerable way outside the back foot, it was thought advisable to give a little additional support to the mould here.

Instead of iron, a piece of half-inch square wood was used here. It was embedded firmly above the base and at its upper end to the outside of the mould and also lightly in the middle. It shows clearly in the illustration on the outside of the completed mould on the left side.

The introduction of wood as a reinforcement for the mould is seldom mentioned in text books dealing with this subject, perhaps because it is liable to swell, has not the strength of iron and cannot be bent to follow the contours of the mould. But in fact it can be most useful and is very often used. It is very light, and where a straight and not too long support is needed wood serves excellently. Moreover, if it is not embedded all over its length and used rather as an outside support, so that it is not entirely covered by the damp plaster, the chances of its swelling and twisting are remote.

In casting large works, more solid lengths of wood are often used for reinforcement,

making, as it were, an attached framework carrier for the moulds, which may be made thinner and lighter when so reinforced.

Such wooden supports may be lightly but strongly attached to the moulds with the assistance of lengths of scrim soaked in liquid plaster. This was explained earlier in describing the casting of the life-sized head.

In making the moulds for the figure here, in addition to the wooden upright on the lower part of the front mould beneath the raised arm, a length of wood was used, similarly, to support the lid leading into the drapery. It was embedded chiefly at the upper and lower ends. As well as strengthening this upright piece of the mould it enabled this small section to be pulled out easily and replaced into the main lower back mould once it had been opened. (Illus. 52, 53, 55.)

As regards the two back moulds, a few short pieces of iron were used to strengthen each piece. The lower mould, which would have to take a fairly considerable strain as it was removed, was mainly reinforced by two lengths of iron reaching from the top of this section, at each side of the hips, down to the base, approaching opposite corners of this part of the mould so that they crossed near their middle. They were firmly embedded at both ends. These irons show clearly on the illustration of the back view of the opened mould with the upper section just removed from the clay model. (Illus. 53.)

Once the moulds had been reinforced by the irons and the wood, further plaster was added to the moulds at any places where a greater thickness seemed to be called for, most notably around the outer edges. Here, it is always advisable to build out the mould as far as the fencing projects from the clay model.

As soon as these final coatings of plaster placed on the mould had set, any plaster covering the top edge of the fencing was everywhere scraped down to the level of the metal with a knife as was done earlier when moulding the head, thus disclosing the fine metal line of the top edge of the fencing, gleaming clearly through the scraped surface of the plaster. It is important to ensure that this operation is cleanly carried out throughout the whole length of the fencing so that the separate pieces of the mould will all lift away easily.

The base-board was also scraped clean from surplus plaster right up to the bottom of the mould.

When the mould has set quite hard, usually this will take place within half-an-hour or so, it will be ready to be opened.

The first piece of the mould to be removed here was the top half of the back mould. As previously described, a chisel was inserted gently into the join with the front mould at the top, and water was poured over it. This operation was repeated each side, and as soon as the very slightest leverage was obtained by tapping the end of the chisel very

gently with a light mallet or hammer, more water was poured in at the top, and this section of the mould was very easily removed (see illus. 53).

Next, the lid mould on the outside of the raised arm and hand was removed, to be followed by the removal of the small section of the mould of the upper arm behind the shoulder. (Illus. 54.)

The removal of the lower back mould had to be approached with some care. First the door or lid in its side, covering the drapery and the hand holding it, was opened by lightly tapping at the join with the chisel here and there, and pouring in water as usual to swell and soften the clay within. Then it was worked open gradually until it could be drawn away, using the upright wooden reinforcement as a handle.

Once this lid had been opened, the clay forming the drapery was carefully extracted and the wires supporting it were cut through. Then most of the clay forming the hand and part of the wrist was removed.

Next, the remaining clay forming the lower arm and wrist was extracted from above, through the opening made by the earlier removal of the top section of the back mould, giving access to the back of the clay model.

The armature piping for the lower arm and hand was now straightened out within the hollow in the lower back mould, entered into by the removal of the pull-away lid or door. The piping was then carefully pulled upwards into the upper part formerly covered by the top back mould. (Illus. 53.)

The main lower section of the back mould running behind both legs and formerly containing the drapery and hand etc., was thus freed from all impediments to movement.

Some very slight leverage was given to this lower section of the back mould by the careful insertion of a chisel in the joint at both sides, tapping it ever so lightly, and pouring water in at the top edge. This lower mould was then gradually eased away from the front mould and removed entirely from underneath the iron by being edged and drawn carefully towards the left corner (looked at from the back view). (Illus. 54, 55.)

It now only remained to remove the clay from the front half of the mould. This clay was first carefully taken away from around the armature in order to free it, and the armature was then pulled right back (see illus. 56). Then the front mould was laid down on its back and the rest of the clay extracted and returned to the clay bin.

The six pieces forming the complete mould (see illus. 57) were each thoroughly cleaned and then brushed over many times with the mixture of soft-soap, water and olive oil, exactly as described when doing the same operation in making the moulds of the life-sized head. This description should be referred to again before proceeding (p. 53, 54).

It was decided to reinforce the figure on the inside before filling the moulds. This

would be particularly necessary with this figure because of the angle of the raised arm which would need support, especially when chipping it out.

A strong galvanized wire was used for this purpose, twisted double right along its length to give greater rigidity and strength. The accompanying illustration showing these wires in position within the front mould, and with the upraised forearm and hand already filled in, should clarify this operation. (Illus. 58.)

Blobs of plaster were placed around the wires at intervals and the wires were then fixed in position within the mould by further blobs of plaster being dropped on to the surface of the mould to attach them to it. Particular note should be taken that they are fixed thus at the base where the wire can be bent into a right-angle and held in position by a blob on the underside flat of the mould, which will, of course, form the top surface of the base in the cast itself.

The plaster to be poured into the mould when filling it will surround and attach these blobs to the cast later, so that they will be incorporated entirely into its mass.

Care must be taken in selecting the positions where the wires are thus to be fixed, for it must be remembered that if the narrower openings in the mould surrounding the ankles, arms, etc., are too greatly filled up by the plaster blobs attaching the wires to the mould, there will not be sufficient space left for the plaster to run through freely, when filling the assembled mould.

The wire reinforcements should run as nearly as possible through the centre of any volumes of the cast, of course, particularly the smaller ones (which will show as hollows in the mould). But above all, care must be taken to ensure that the wires do not touch the surface of the mould anywhere.

For larger figures, iron of appropriate thickness, according to size, should be used to reinforce the cast. These irons should always be covered, first, with some damp resisting substance such as Japan or Brunswick Black, to prevent discoloration of the cast by the iron rusting while the cast is drying out.

Wires may be used in conjunction with irons when small projecting volumes, as for instance separate fingers need reinforcing.

As soon as the reinforcing wires here were fixed into the front mould, as shown in the illustration, the small mould covering the outside of the upraised forearm and hand was replaced on to the front mould and fixed tightly in position, both with cord and by the addition of some fresh plaster round the joint with the front mould. This plaster was applied here to hold it in position because the cord tying it will need to be removed temporarily once this section has been filled, in order to allow the other pieces to be replaced.

The whole front mould with this small section fixed on, was then turned to stand

82

head downwards and some freshly mixed plaster was run down through the opening at the bend of the arm to fill the forearm and hand. The mould was moved about to ensure that the plaster ran right down to the finger tips and a little more plaster was added, intended to project into the mould of the upper arm when set. Once this had become hard the cord tying it was removed and the mould was placed upright on its base again and it was photographed for the illustration showing the front mould with the reinforcing wires in position inside. (Illus. 58.)

The small mould adjacent, at the back of the upper arm, was next replaced on the front mould. It was tied up to it by cords passing through the opening on the outside of the front mould, underneath the arm and round the top mould now covering the outside of the upper arm and hand.

(A very thin covering of plaster was also used here, just sufficient to seal the joint from leakage, when the plaster filling making the cast was poured in—this precaution was repeated as each following piece of mould was finally put back into place.)

This upper arm was then filled with freshly mixed plaster, poured through the shoulder, thus joining it to the upraised forearm. It was, of course, reinforced within by the twisted double-wire at the bend of the arm. This support continued right up through the forearm and hand, nearly to the finger tips.

The top back mould was then replaced on to the front mould and tied tightly to it with cords. This portion of the whole mould was then filled—head downwards as before.

Fresh plaster was mixed and at once run into the tied-up mould. The mould was moved and shaken about, a number of times, to make the plaster run into and over the face of the front mould—it was run back and forth until it began to thicken. Then it was run back, and left to set in place. Meanwhile a soft, wet sponge was kept handy and constantly employed to remove any liquid plaster which might settle on the edges of the mould formed by the fencing. Any speck left to harden here, would, of course, have prevented the lower mould being tightly refitted. (See illus. 59.)

The bottom half of the back mould was then fitted tightly into place and the lid or door in the side (around the drapery and hand) was put back into position in its side. The whole reassembled lower mould was then tightly tied to the front mould with two sets of cords running right round the mould and passing inside the iron and wood reinforcements where possible. (Illus. 60.)

Fresh plaster was now mixed and poured through the apertures in the base for the ankles and drapery, until the level of the plaster covered the top of the base while the whole mould stood head downwards.

This liquid plaster was poured out and back more than once, and the mould was moved around and slightly shaken to ensure that it was completely filled and free from air.

83

As soon as the plaster began to thicken it was left standing head downwards. Some more plaster was then added so that the mould surrounding the base was filled just above its top level—this flat surface will, of course, be the bottom of the base when it is standing in its proper upright position later.

A flat strip of smooth wood was damped and then passed quickly to and fro across this surface as the plaster began to set, removing any superfluous plaster, and thus smoothing it level with the bottom of the base of the mould—both ends of the slat of wood being supported by the bottom of the mould during this operation.

The whole work was now left until the plaster was absolutely cold and set hard— it should be left for an hour at least, preferably for a few hours, better still, overnight.

Once the plaster had set hard, some evenly folded scrim (any suitable material would do) making a soft bed, was laid on the modelling stand. The mould with the cast inside was then placed standing upright on its base on this bed, ready to be chipped out.

The process of chipping out followed the same lines exactly as that of the life-sized head described earlier, but on account of the comparative fragility of the figure much greater care and a little more forethought was necessary. The principle of always leaving the mould below intact to support the more breakable projections, until the weight of the mould above has been removed, was particularly necessary here.

Consequently, as soon as some of the upper mould was chipped away at the top of the figure, the centre iron was first removed and also the iron down the front of the lowered upper arm which cuts across the centre of the figure. But the other irons were left in place. (Illus. 61, 62.)

Then the outside white mould on top of the upraised arm and hand was carefully chipped away and the forward iron supporting the mould under the arm at its centre was removed. (Illus. 52, 61.)

But the iron supporting the elbow, which was also strongly embedded right down the mould in between the front of the legs, was left in place to support the arm until this was completely and carefully freed from the mould. The first illustration of the chipping out of the figure will show this iron still in position very clearly. Indeed, most of the figure was freed before this iron was removed entirely, in order to protect the arm from any possibility of fracture while the mould was being chipped away from all the upper part of the figure. (Illus. 61 to 64.)

Likewise the mass of the mould underneath the upraised arm was left intact until all the white mould was removed around the head and torso. The piece of supporting wood also was removed while the iron under the elbow was still left in place. (Illus. 64.)

The chipping out was then a fairly straightforward job. The heavy white mould was chipped away all round the figure, always, however, leaving plenty of mould in place

to support the fragile parts such as the inside of the lowered arm, the hand and drapery, until the outside weight of white mould had been removed. Likewise, plenty of the mould was left around the ankles and in between the legs until the heavier mould outside had been removed. (Illus. 64.)

Once the chipping out was started down here, the two irons surrounding the base—one on each mould—were removed and then the white mould was chipped away around the lower part of the figure. Only then was the iron supporting the elbow freed. The small piece of mould remaining under the elbow where the iron had been embedded, came away very easily once the iron had been freed from below, and removed. It had barely to be touched with the blunt chisel, which was tapped very lightly, to make it fall away downwards from the elbow. (Illus. 65.)

When the cast had been completely freed from the mould, any chisel marks on the cast were repaired with "killed" plaster, as with the cast of the life-sized head.

The numerous seams marking the lines of fencing where the moulds had joined together were removed with a knife. The figure was turned around so that the light gave the maximum shadow to the seams during this operation, thus showing them up most strongly. (Illus. 65.)

Here and there, where the filling had somewhat swelled the mould, a slight "step", from one side of the seam to the other, or a sunken line showed in the cast. In such places the surface was regained by thoroughly wetting the blemished part, after roughening it with the serrated edge of a steel tool, and then applying drops of liquid plaster on to it with a brush, quickly smoothing this new plaster level with both surfaces of the cast, beside the line where the seam had been. The spatula end of a small steel tool dipped in water was used for this operation—drops of water from the end of the spatula were constantly trickled on to the fresh plaster, while working, in order to facilitate this smoothing of the surface.

One other thing might be added to this account. When some experience has been gained into the way in which plaster sets and its rate of setting, it may be easier or more desirable to fill shallow parts of the mould by "squeezing" rather than running the plaster into them. The small moulds in the upraised arm, here, for instance, would probably be filled in this way by an experienced moulder.

By this method, both halves of the mould would be filled with plaster, one side at least being left with a little more plaster in it than would be required to fill this part of the mould. In this state the smaller piece of the mould would have to be speedily and firmly replaced in position on the front mould, so that the superfluous plaster would be squeezed out as the moulds are pressed tightly into place. The mould would then have to be tied together as before and so held in position until the plaster filling has set hard.

As this operation necessitates the plaster being in exactly the right state—if too liquid, it will not keep its position and the mould will not be completely filled, if it has set too far, the moulds will be prevented from closing tightly—it is not recommended for the inexperienced. But a "squeeze" mould can often save much trouble in filling small recesses which are difficult of access for running in liquid plaster.

Another consideration, more particularly with somewhat larger figures, is to make the cast as light as possible, for, of course, as was mentioned in casting the life-size head, a light cast is both stronger and more easily transportable. In such cases the larger volumes, particularly the torso and sometimes the head, may be left hollow with great advantage. But this may necessitate the moulds being made in a greater number of pieces in order to gain access when filling; for a figure of the dimensions described here it is better and simpler to fill the moulds completely.

WORKS IN RELIEF *chapter 10*

A sculpture in relief is one in which the configuration of the work is attached to a background, as opposed to a sculpture in the round which can be freely viewed from any aspect.

Nominally reliefs are of three kinds; high-relief (alto-relievo), low-relief (basso-relievo) and middle relief or half relief (mezzo-relievo), of which descriptive terms, high, and low (also called bass or bas) relief are in most common usage.

In fact, a relief can range from something like an incised drawing to an almost fully modelled figure—so long as this latter is not detached altogether from its background.

In essence then, a relief is an image formed on a flat surface, by a modulation so slightly raised, that it requires a strong oblique light to show its presence; or by so bold a modelling that it might well be a sculpture in the round, except for the missing viewpoint where it attaches to the background; except also, that is, for the fact that its form has usually been conceived by the sculptor in relation to the background. It is always intended to be seen more or less frontally; usually, so that it will disclose the sculptor's conception as an emergence from a solid block, or slab, in which the background has been gradually moved back, to disclose the sculptured configuration as a partially freed design, inhabiting the material from which it has been made.

This latter idea is perhaps more pertinent to the mode of glyptic than of plastic work, although technically there is nothing to prevent a solid mass of clay—preferably with one of its surfaces flattened—being cut back to form a relief, high or low; and indeed this method of procedure is often both used and recommended.

With stone itself this cutting back of the relief (and the gradual lowering of the ground around it) certainly does give a feeling of unity and above all a sense of relationship to the matrix—the block of stone from which the relief has been made to emerge. Michelangelo, indeed, quite consciously, conceived all his stone (marble) figures as always being already contained within the matrix. His business, he felt, was only to free them, more or less, in order to give them life. His unfinished "Slaves", still emerging from the block, illustrate this mode of thought with clarity and with great feeling.

Rodin, who was essentially a modeller in clay rather than a carver *per se*, was so susceptible to the attractions of this approach (which itself suggests by the visible act of emergence from the parent, the bringing to life of the configuration), that to innumerable sculptures, actually modelled by him in clay before being copied in marble, he added a matrix, often larger than the sculpture itself.

With Rodin then, the creative sensation of emergence from the matrix was to some extent a second-hand, even a somewhat spurious effect of collaboration with the material —which was, of course, clay and not stone, in the original—but it was none the less an imaginative tribute to the fundamental character of the background material (marble) in which these particular sculptures were finally made (or copied), often by quite other hands.

These theoretical questions of imaginative collaboration with the material—questions both aesthetic and technical—are interesting ones and well worth pursuing from many different angles. The particular question as to how far an act of imagination can make a form in clay suitable to be fully transposed into a different material such as stone, the working of which requires a different, if not altogether opposed, technical approach, is one which has assumed quite important proportions at many different periods of sculptural history (periods assessed variously as decadent or exactly the contrary, very often by valuations conditioned more by the current technical practise of sculptors themselves than is allowed for by critics, who often follow technical trends when they suppose they are assessing fundamental value).

Here, we must, perhaps, again merely stress the not unreasonable proposition, that forms in clay are most naturally made by the addition of soft material, rather than by the process of cutting down, or otherwise making reduction, which is of course, the only mode of procedure possible when shaping a hard material such as stone. None the less it is quite possible, of course, to reduce clay also by a process of cutting down. The clay can even be allowed to harden somewhat, in order to provide, partially at least, the resistance for any cutting or carving operation which should leave the form thus arrived at, reasonably sharp, rigid and undamaged.

Thus far, clay may be considered to some extent as a material which can be shaped both by being built up or cut down. To some extent also this is both its strength and its weakness as a medium. A strength because it allows for correction, alteration and second thoughts, giving great freedom of approach in materializing ideas of shape without hindrance; a weakness in so far as it permits facility, and the adoption of accidental suggestions of form more akin to painting than sculpture, which may well be allowed to supplant direct statements of clear articulate form.

Moreover, another consideration which might well be put forward in clarifying this

matter of technical procedure is that, in so far as clay is permitted to harden in order to make it a more suitable medium for the process of cutting down, it approaches the condition of a soft stone; in so far as it is suitable for building up, it is approaching its most characteristic and attractive condition for handling as a medium.

Earlier in this book, when dealing with the making of sculpture in the round, particular stress was laid on the importance of building up the forms outwardly by a gradual accretion of soft clay, applied for the most part in pellets, thus giving expression to the idea of a unified growth of the form from within—a natural expansion of the design from the centre as it were. This is of absolutely fundamental importance—as it is also of fundamental importance with stone cutting to think of very gradually reducing the hard block towards the desired form within it, so that this final form may be left with its maximum mass-potential.

It is often the custom in text books to present the making of a relief as a simplified first essay towards sculpture in the round. This is because a relief, particularly a low relief, necessarily partakes somewhat of the nature of a drawing on the flat, and as it approaches a high relief therefore, it must to some extent help the student to develop with it, also, a sense of sculpture in the round which requires a realization of volume and plan. In addition, the moulding and casting of a relief is a much more simply grasped procedure than would be the case with a piece in the round.

Here, however, the making of a relief has been considered last, because it is believed, on the contrary, that drawing itself may best be realized, in its fundamental meaning, by direct and immediate apprehension of the nature of solid forms and their basic shapes in the round; and also because the expression of solid form by means of more or less flattened form (which shall none the less suggest full sculptural form) can be an altogether more subtle operation. It calls for a transposition of all the projections and recessions in true relationship one to the other in order to give true tonal values, and this can certainly call for a more indirect and suggestive approach than would be the case with the making of simple forms in the round.

In making a relief which is a true relief, as distinct from a figure in the round not entirely detached from the background, the question of lighting becomes a factor of considerable importance. If the relief is a very low one it will require a strong light to make it visible at all in its true modelling. It can read very differently according to whether the light strikes directly on to the front, back, or top edge of the relief itself.

The relief will read most easily if it can be placed so that the light strikes the subject fairly strongly from the side and top — that is, obliquely at about 45 degrees. The relief will usually look best in the same lighting in which it has been modelled, although it will be as well to work on it now and again in a different and even in an opposite lighting,

89

so that the shadowed side may be seen in the full light and the forms completed in different lights. To be seen to advantage the relief should not be turned at too direct an angle to the light—which will tend to over-emphasize the projections and depressions and to darken the background—but only at such an angle that all the modelling is clearly readable. Some light should be allowed to illumine the whole surface, including the background.

Presuming the relief to be a configuration projecting to greater or lesser degree from a flat background—and not merely a section of a fully modelled figure in the round stuck on to a background, which is no true relief at all—then the outline pattern which it makes with the background will be, as with the drawing, of prime importance in giving vital impact and rhythm to the whole work.

There are many ways of using and varying this junction of the outside of the raised form of the relief (or main relief) with the background (or with any subsidiary background relief-work). In its simplest essential a relief may be merely a flat shape—figure or pattern—separated from its ground, either by the background being sunk back around its outline, or by the shape enclosed by the outline being raised up from the plane of the background.

It will be seen at once that the first method suggests cutting back the clay which is to form the background and is in a sense more suited to carving a hard material—though this can, in fact, be done quite easily in clay by using a flat-ended wire tool—whereas the second method is more suited to clay thought of as a soft pliable material.

In practise there is nothing very much against either method in commencing a relief. As with the making of a head in the round where, at a certain early stage, it was suggested that the main thing was to establish the major planes, without letting any too purist a technical view hold up this essential drive towards underlying basic form, so it is advised here that the most direct way to the essential form of a relief should be taken without any inhibitions of too much aesthetic theory. None the less, with modelled relief, as with sculpture in the round, in clay the main drive should be carried out and thought of substantially, as of something growing outward by the addition of clay—in the case of a relief, as growing out from the background. Some further comment will be made later, on this matter regarded as a practical issue.

Exercises in Relief

It may be as well to carry out some exercises in simple formal relief before proceeding to more complex ones.

The illustration shows some geometric solids—a cube and a sphere, each placed on a receding rectangular plane—roughly transposed into relief. (Illus. 66.)

These miniature reliefs were made on a small panel of more or less flattened clay as a background. They were first roughly drawn in line with a pointed tool and then the reliefs were built up in projection within the lines.

The first cube, of course, has the smallest actual projection; in the lower figure, the actual projection from the background of both the cube and the rectangular plane is considerably greater.

Likewise, the upper sphere (or circle) has a very slight actual projection and the lower one a very much greater projection; also the plane on which it is standing has been developed from the indication in line which has been left in the upper figure.

In making these very simple reliefs it will be found, of course, that the perspective of the outlines by themselves will give some suggestion of solid objects; but the raising of the drawings into different degrees of relief to show changes of plane and to accent projection will give immediate entrance into the problems of working in relief.

The slightest definite turn on the planes, at the sides of the design catching the light, will be found to suggest an added dimension. In addition to the making of inclined flat planes, as for instance the top of the rectilinear figures supporting the cubes and the spheres, experiment should be made to give a slight concavity to some of these planes and observation should be made as to the suggestive quality of the added light (or shadow) thus gained.

Likewise, the relief of the sphere should be modelled back towards the background from different circumferences within the main circle. The effects of distributing the light and shadow around it by this means of different inclination of the plane turning towards the light, and the possibility of suggesting different degrees of projection by this means, should be carefully noted, and weighed against the effect of actually enlarging the projection of the clay in reality.

Where the relief meets the plane of the background some incised line may be used as an accent here and there, and the varying effects of using this line or leaving the relief to make contact with the ground cleanly, can be observed—a sharp or soft liaison here can also be used with different effect.

In fact these and like exercises should be used to investigate the suggestive effects of light and shade and pattern on slight, and less slight, inclinations of the surface, noting the way these planes contrast with each other and with the simple flat plane of the background.

Later, the forms of any subject-matter whatever may be attempted. Leaves, vegetables, fruit, flowers, animals, figures—preferably somewhat formalized or stylized —may be modelled in relief. That is to say, their more generalized and decorative character should be stressed, rather than their more separate individual features, with

the inevitable accidental deviations of form which occur in all organic growths. To discover and to express the rhythmical pattern of their typical form of life is the important thing.

Such leaves as those of the vine, for instance, with their immediately attractive silhouette, especially in conjunction with the springing curves of the branches from which they grow, with their tendrils and the contrasting smooth, rich forms of the fruit, at once lend themselves as suitable subject-matter for decorative relief.

None the less, the exercise of making contrasting geometric forms in relief, first separately and then in relationship one with the other (noting the effect of the light on the lowering and raising of simple planes and also on the shaping of concave and convex surfaces), is most likely to give a speedy grasp of the possibilities of linear and surface arrangement within the comparatively narrow range of projection essential to a relief.

Once control is gained of the tonal possibilities available from low to high relief, then subject-matter and its treatment can cover an immense range. Here however, a warning should perhaps be given.

Owing to the pictorial possibilities of relief—that is to say, the possibility of suggesting realistic form in depth by means of both linear and tonal perspective, there is always some danger of making pictures in relief instead of sculptural designs.

The classic example of such pictorial works in relief are, of course, the famous Baptistry doors of the Renaissance sculptor Lorenzo Ghiberti in Florence—the "Gates of Paradise"—where the formal and rhythmical qualities essential to sculpture proper, whether in the round or in relief, give place to the creation of illusionist depth in the pictorial sense, so that even Ghiberti's supreme craftsmanship is unable to convey the sense of controlled formal vitality present in all great works in relief.

The great sculptural reliefs, whether from Assyria, Egypt, India, China, Greece or elsewhere, will always be found to have a formal relationship in their parts and a rhythmical vitality, rather than a realistic spatial one, in the pictorial illusionist sense.

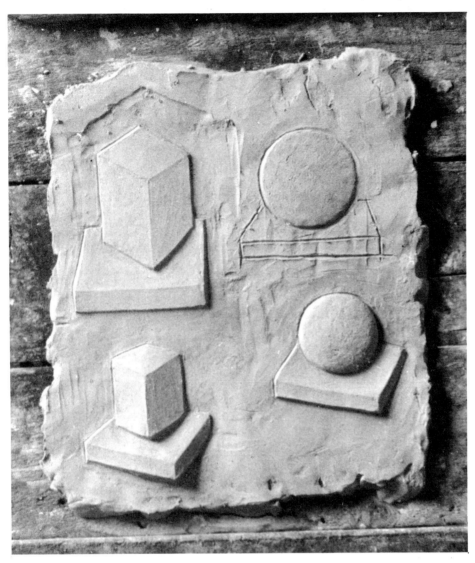

66. Exercise in relief

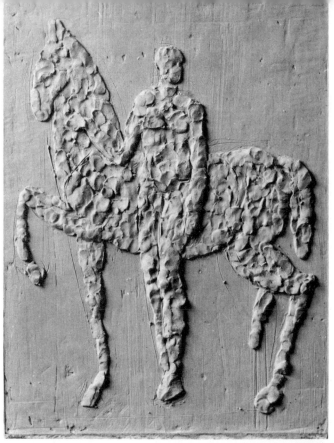

67. First lay-in of the relief in clay.

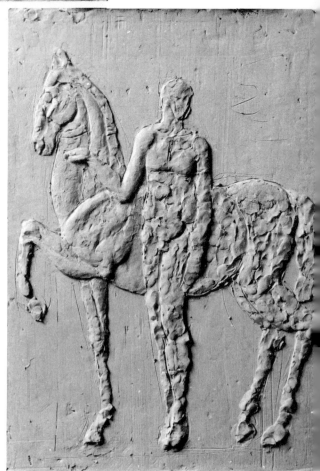

68. The modelling slightly developed.

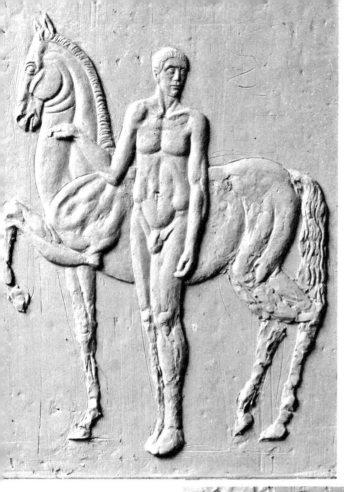

69. The clay model nearing com-
pletion.

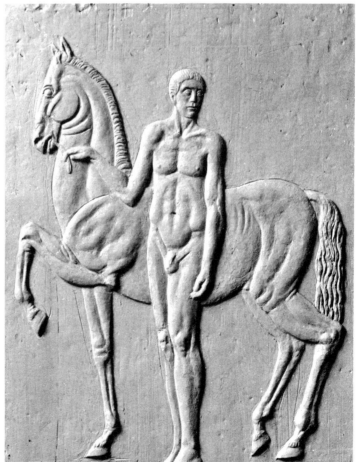

70. The clay model. Final state.

71. Clay wall erected round the relief to contain plaster to be poured in to form mould.

72. Mould reinforced with wood.

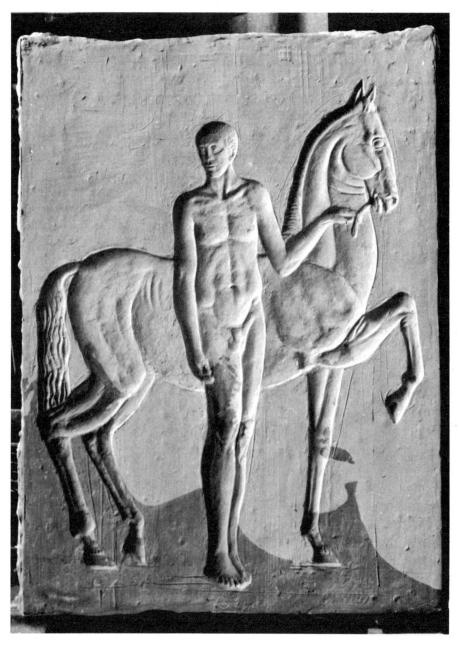

73. Mould of relief with clay removed.

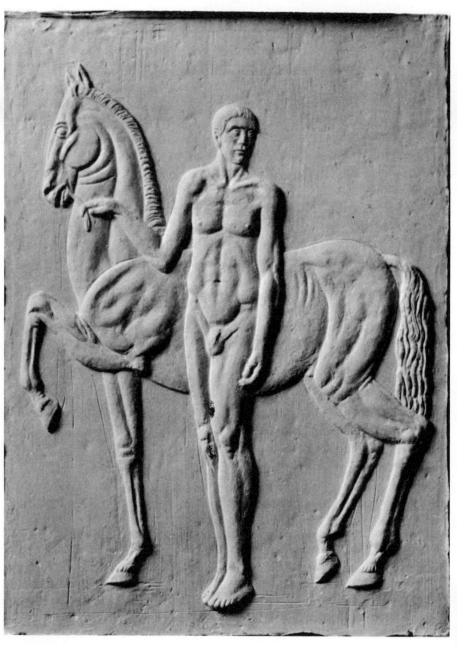

74. The plaster cast, freed from the
mould.

MODELLING A RELIEF *chapter 11*

The first necessity for making a relief is, of course, a support for the clay.

A wooden board is the simplest and most obvious one for a relief of moderate size. It can be made very much in the way the base-board was made earlier. But as the wet clay will be applied directly to the surface of this board and will remain in contact with it until the work is completed, all possible precautions should be taken to prevent the wood from warping.

For very large reliefs a plaster slab is often used and the back of the plaster slab can be damped as well as the front of the model. But this makes the work very heavy to move and had better not be attempted early on.

For very small works a piece of slate is sometimes used—but in the first instance, a wooden board is most strongly recommended.

For the making of the relief illustrated here, which measures 28 inches by 21 inches, three 28 inch lengths of wooden board each 6 inches wide by ¼ inch thick (and also one 28 inch length of wooden board 3 inches wide and of the same thickness) were laid lengthways, touching each other, on to two cross batons each measuring 2 inches in width by 1 inch in thickness. These were placed nearly at the top and bottom of their length. The third cross baton measured 4 inches in width and was of the same thickness. It was placed across the middle of the boards. The boards were then nailed firmly down to the batons with galvanized nails. If screws should be used, slots rather than round holes would allow for some swelling and contracting of the wood. The wider baton was used at the centre in order to hold the boarding very firmly in position if it became affected by the wet.

The whole board was then heavily coated three or four times with shellac varnish (white polish) until it showed a hard shiny surface.

The simplest way to obtain a flat surface of clay to form a background on which to build the relief—or a surface from which to lower the background—is to nail round the outer edge of the board, strips of wood with a depth equal to the required depth of the clay ground. Here, ½ inch square lengths of wood were lightly nailed to the board at the outer edge, down both sides and along the bottom.

The board was then covered with soft clay, completely filling the shallow well, made on it by these strips around the edge. The clay, in large pellets, was firmly pressed down to the shellacked board—if the clay is not firmly pressed down and air holes are left beneath, the ground will later become lumpy and a lot of time can be wasted in obtaining a flat surface again. A length of smooth wood—any good, firm sort of ruler will do for this operation, a slightly toothed one will give a texture if required—reaching across the panel of clay from side to side, and with both ends resting upon the outside strips of wood, was dragged very firmly from top to bottom of the panel until the superfluous clay was removed and the surface left level with the strips.

The flat panel of clay was then left for some hours to harden a little. At the end of this time there was some little shrinkage of the clay particularly where it touched the outside wooden surround. Further soft clay was applied and the ground was once more quickly smoothed over with the ruler. The whole panel was then left exposed to the air for a short time until the background became firmer.

The board with the clay panel on it, enclosed on three sides by the $\frac{1}{2}$ inch wooden strips, was then placed upright on an easel ready for work.

Some wooden modelling stands are made with an additional tip-up adjustable top, hinged at one side to the turntable and with a ledge fixed at right-angles to it here, which will hold a relief when the hinged top is elevated from the opposite side. It is held in position by a supporting iron, also adjustable, in the manner of the metal arm which raises an open roof-light (by holes along its length being fitted over an iron projecting stud, as it is pushed to different heights).

Failing some such contrivance, or a solid easel, the panel will have to be placed on a table or bench and leaned against a wall, if possible attached to hooks in this latter by cords passing through eye-hole screws in the side of the panel.

In order to keep a clay panel damp when not working upon it, it is better to lay it down flat and cover it over with damp cloths, laying a sheet of plastic material on top to prevent the air getting to it. Of course, if desired, the actual surface of the relief may be protected when the work is further advanced, by placing skewers in the background to keep the damp cloths from contact with the relief itself; or else wire bridges over it may be made and the ends inserted into the background. They serve the same purpose and give even greater protection.

Having placed the panel in an upright position in a good side (and top) light, the main outline was freely drawn with the edge of a nearly pointed wooden tool, in incised line, on to the flat clay surface.

The subject chosen for demonstration was that of a horse with an upright male figure beside it. A very slight and tiny sketch was first made on paper to give the spacing

NOTE FOR RELIEF

and the all important general rhythms of this composition.

If it seems preferable to make a careful full-size outline drawing of the subject first, this drawing can of course, be transferred to the panel from tissue or other soft and thin paper by pricking holes along the lines, by "squaring up" (that is, by dividing the space on both the drawing and the clay panel into similarly proportioned geometric spaces such as squares, and drawing on to the clay each part of the design which appears in these comparatively small proportionate spaces, until the whole drawing is transferred in correct proportion), or by any other means at all which will transfer the drawing on to the panel truly.

But it is usually better, in the sense that it allows more freedom, to draw the design directly on to the clay. Any error which may appear can be very easily corrected as the work proceeds.

From this point, as mentioned earlier, there are two possible modes of procedure. The relief may be built up above the background within the outlines, or the background may be sunk around the outline by being cut back with the flat end of a wire tool.

95

As regards the second method, it may perhaps be mentioned that reliefs are, perhaps, most often made for the purpose of architectural wall decoration. Models are first approved by the architect when in clay, therefore, in which form they can easily be altered or modified. The model once approved is then cast in plaster. This plaster cast is now used by the sculptor, or by masons working for him, as an original to be copied, more or less exactly, in stone.

Whether this method is justified aesthetically cannot be argued here, but the fact remains that much notable architectural sculpture in relief, including possibly the Parthenon frieze itself, in whole or in part, has been carried out by this method. Doubtless the stonecutter-craftsmen, the designer-sculptors, whether Assyrian, Gothic, Indian or other—the men who lived and thought in stone would always have carved the architectural stone fabric direct.

To some extent, this extensive making of models for carved relief would be consistent with a cutting back of the background plane to start with, and then more or less carving the flat surface thus left elevated within the outline, into the final relief.

This work, which would be carried out on, and into, the somewhat hardened clay slab has, for the purpose, the added virtue, that the top surface of the relief will never project beyond the surface of the original clay slab. Thus, the whole relief will always be contained within the depth between it and the sunk background—a matter of some importance when cutting a relief in stone to an architect's specification by the means mentioned above.

None the less this method is really more an approach to carving in a very soft stone. The method of building up the relief with soft clay within the outline has, therefore, been followed here.

The main lines of the composition having been roughly indicated on the clay slab, the whole shape of horse and man was loosely filled in with flattened pellets of clay. Only the more prominent parts of the relief were slightly built up at this early stage. The photograph for the first illustration of the relief was made in this state in a very strong lighting, which makes this first lay-in of the shape look as though it is in rather more considerable projection from the background than was actually the case. (Illus. 67.)

But the arms and figure generally—the jawbone of the horse, etc., may be seen in some slight relief even in this first rough stage. The proportions—length of legs, etc.— were somewhat faulty and to be corrected later, but none the less, the first speedy build-up of the relief at once gave substance to the subject and showed its capacity to fill the shape of the panel in an effective manner. This first project is wholly important to the character of the final work and should be laid in with full vigour.

Next, the head of the horse was developed a little further and the general mass of

the neck enlarged, while the shoulder and front leg were modelled and brought up nearly to full prominence here and there.

The raised arm of the man was also developed, so that it became, as it were, a standard of the measure of projection for the relief of the figure in front of the horse. This projection was in fact less than $\frac{1}{4}$ inch here. At no point in the final relief was the projection as much as $\frac{1}{2}$ inch—the highest point of projection being the lowered hand of the man, in the completed work. (Illus. 68, 70.)

Some correction was made at this early stage, also, in lengthening the legs of the man and shortening the legs of the horse—but the final adjustment here was left until later on as it seemed more important at this stage to keep the impression of the elongated space-filling verticals of the legs, rather than to reduce the design to naturalistic proportion.

The modelling of the whole group was then brought up to the same stage as that of the horse's head, shoulder, and front leg, with some correction in proportion of man to horse. Particular attention was then given to the outside shape which the relief made on the background.

Everything was done here to emphasize the rhythmical lines of the horse, and some incised line was used here and there to sharpen the junction of the relief with the background. The rhythmical lines were emphasized within the structure of the group itself— the shoulder blade, neck muscles and bony structure of the head and legs of the horse were all given almost geometric stress to emphasize the lines of movement, while the figure of the man was kept stiffly upright as a foil to these springing lines in the design.

Some of the forms were rounded towards the light to give breadth and softness. Some of the returns, particularly towards the background at the edge, were cut back squarely to give incisiveness to the design as a whole. This is important in a fairly low relief as too soft an approach to the background, and also from one plane to the other, can devitalize the work, although it may give it refinement. It is all a question of intention.

Finally, the hair was used as a textural enrichment in the mane and tail, above the hooves and on the man's head. In the tail and mane, pattern was stressed in a somewhat decorative and arbitrary manner in order to give variety of surface and also to hold the eye.

The foreshortened foot of the man was kept well within the depth of the general projection. It is in such features that there is a temptation to model in too great illusionist projection out of keeping with the general character of the flattened relief. The front toes, here, project just over $\frac{3}{16}$ inch from the background—that is to say, not much more than the frontal projection of the figure to which it belongs. (Illus. 69, 70.)

Where the top of the tail isolates a small piece of the background against the horse,

97

this background was brought forward a little as it gave too great a dark when left at the original level. This matter of isolated wells of over-dark tone, is one to be looked for and corrected over the whole relief, as there is always a tendency when first engaged on making a relief to overstress the modelling, which will tend to give a restricted spatial feeling.

A nice point between the emptiness of too little modelling and the lumpiness of over-emphasis is something to be sought for. Simplicity gives breadth—over-emphasis of modelling and detail, smallness.

The deepest hollows should be somewhat above the background level, the greatest actual projections should not approach sculpture in the round—unless the relief work is to be regarded simply as an unfinished work in the round.

If the relief seems to be overloaded in modelling, do not let any considerations of cutting down in clay inhibit the work. Cut down ruthlessly with a wire tool; or actually cut the offending piece right off down to the background, with a piece of taut wire held in both hands; and then build up again—with greater care.

A beautiful or otherwise expressive distribution of projection and recession, making the tonal relationship of the lights and darks meaningful as design and well integrated over the whole panel, is the desideratum.

Turn the panel into different lights in order to bring it to completion, particularly in order to observe the shadowed edge in the full light where it may then look ragged. When completed, the panel must be laid down on its back in order to cast it into plaster.

WASTE-MOULDING
A RELIEF

chapter 12

Making a cast of a relief is a comparatively simple matter. An enclosing wall surrounding the relief must be erected. This must be sealed both underneath and all around its length, so that it will safely contain the liquid plaster which will be poured over the relief to make the single necessary mould.

If the relief has no undercuts whatever it will pull away cleanly from both model and cast. In this case further casts may be taken from the same mould and it cannot properly be called a waste-mould.

If the relief has any undercuts at all the mould will not pull away freely and the first coating of wet plaster to be laid over the clay model should be tinted, as in the waste-moulding described previously. The mould will have to be removed from the cast by chipping it off in the manner described earlier.

The relief shown here was laid flat on its back and a wall made from strips of clay 2½ to 3 inches broad and about ½ inch thick, was built up on top of the strips of wood surrounding the clay panel. This clay wall was placed on its ½ inch thick edge to make contact with the wood surround, so that the wall stood above the panel to a height of nearly 3 inches. The clay was carefully pressed down on to the wood all round and also sealed by being pressed on to the outside of the strips of wood and board as well. A wooden spatula tool was used to trim the contact of the clay wall with the background and to ensure that the wall did not overlap the clay ground of the panel (see illus. 71).

As it was desired to make the mould not more than 1 inch in thickness, marks were made at this height on the inside of the wall, above the panel, to act as a guide when covering the relief with plaster.

Another way would have been to remove the surrounding strips of wood and attach the clay wall to the board instead. If this is done and any space of wood boarding should be left surrounding the panel, it will be as well to give the bare wood a good coating of clay-water or soap, so that the mould will not stick to it when it is being removed from the panel later on.

A bowlful of plaster was then mixed, with colour first put into the water as before, in order to differentiate it from the subsequent coats of plaster when chipping out.

This tinted plaster was then poured over the top half of the panel. The panel was slightly lifted, and moved and tilted about to ensure that the plaster ran into every hollow. The plaster was also forced into crevices by blowing hard upon the surface—particularly over the horse's head and mane, over the man's head and over any other places where the recesses were more sharp and deep. This was done speedily and the panel was then rocked about in order to level up the stiffening plaster.

It would have been useful to be able to mix sufficient plaster to give the whole face of the relief one all-over coating with the first bowlful poured in—this would have called for the use of a larger bowl than the one specified.

As it was, the same sized bowl was used. Another bowlful of the plaster with colouring matter in it was quickly mixed and at once poured into the lower half of the panel in the same way.

As it was setting, the surface of this coating of the tinted plaster, now covering the whole relief, was run over very speedily and very lightly with the finger tips in order to roughen it, so that the subsequent outer coatings of plaster would adhere better to it. Of course, it is important to carry out this operation very quickly and lightly so that the surface of the clay below remains quite untouched — if there is any doubt at all about being able to do this and the level of the plaster looks too smooth, it will be far better, as was previously done, to throw blobs of plaster on to the surface in order to effect the same purpose.

Because of the flatness of the panel the level of plaster poured over it will always tend to run very flat and undercoatings will nearly always be better for some roughening.

As described before when making moulds, once this first coating of coloured plaster had set, some clay water was daubed over it with a brush in patches here and there, though nowhere right up to the outer edge.

Following this operation, further coatings of white (uncoloured) plaster were poured on to the mould until at least another $\frac{1}{4}$ inch of thickness had been added.

It was now necessary to think of reinforcing the mould—which by this time would be about $\frac{1}{2}$ inch thick (and measuring 28 inches by 21 inches in area).

If irons of suitable size are available these may, of course, be used, as before, to reinforce. They will need to go up and down the sides of the panel and across the top, bottom and centre at least. But irons are inclined to make a heavy mould although they are an excellent reinforcement.

In moulding this relief, however, some lengths of wood, which chanced to be ready to hand were used instead. These lengths measured about $1\frac{1}{2}$ inches wide by $\frac{1}{2}$ inch thick. The intention was to make a firmly attached framework or cradle to support the whole slab of plaster. Two pieces of the wood were laid down one on each of the longer sides

of the mould placed parallel, about $1\frac{1}{2}$ inches from the outer edges. (Illus. 72.)

Strips of scrim had been previously cut into lengths of 9 inches to 1 foot, and about 3 inches wide (these measurements are quite approximate). Some of the shorter pieces of scrim were now dipped and soaked in a bowlful of wet plaster. They were quickly wrapped round each of the wooden supports at the centre and near each end, and then the loose ends of the scrim were flattened out on to the mould.

Two further pieces of the wood, each more or less as long as the width of the mould (it may be better to cut them to exact length, of course), were then quickly placed transversely across the first pieces of wood. These were placed about $1\frac{1}{2}$ inches each from the top and bottom edges of the panel and parallel to it. The slightly longer strips of scrim, soaked in liquid plaster, were used here to fix these wooden supports down to the mould in like manner. Ties of scrim were also used at the corners to attach these second lengths of wood both to the first wooden supports and to the mould below.

The longer lengths of scrim were used to carry out this operation because, of course, laying the shorter lengths of wood on to the longer runners raised them from the plaster surface of the mould and left a gap between these cross pieces of wood and the mould itself. But no fear need be felt as to their being insufficiently strongly attached. Ties of soaked scrim become very strong as soon as the plaster sets and it will not matter at all if the gap remains, so long as ties to the mould are made at least in the centre and at the ends of each cross-piece of wood, and firmly embedded on to the back of the mould. (Illus. 72.)

The centre of the panel was the one weak spot remaining. A length of wood—was placed diagonally across the rectangle made by the first four pieces of wood reinforcement. Where the diagonal crossed over the longer upright lengths, it was fixed down with ties of scrim placed at both ends. Two further ties at intervals in the centre were made to ensure that the diagonal wood was firmly attached to the mould here.

This operation of fixing the ties should be done speedily and deliberately, always spreading out the scrim as flat as possible and quickly running some further liquid plaster over the flattened out scrim. This further plaster should adhere well as the scrim will be already well soaked in plaster. As soon as the whole tie has set hard it should make a rigid and immensely strong attachment.

Once this operation was completed, further plaster was poured on to the back of the mould until it was about $\frac{3}{4}$ to 1 inch thick, all over. It was then left for a good half-hour to set thoroughly. The illustration of the back of the completed mould should clarify this whole operation. (Illus. 72.)

If the relief is a very low one the mould should lift away from the clay model very easily. In any case the state of the clay model will immediately show any unsuspected

undercuts when the mould has been removed, by reason of the clay overhang being torn away from the model by the harder mould.

If there is any difficulty in separating the mould, both panel and mould should be placed on edge leaning against some wall or other backing. A blunt chisel should be slightly inserted in one or more places for leverage and water poured in, as described before, to swell the clay. The mould can then be carefully edged away from the model.

The wooden framework supporting the back of the mould will probably be found to be very useful for handling the mould. The ties of scrim, if they have been properly applied, will have made it perfectly safe to lift and lower the mould while holding it by this framework.

Once the mould has been removed the procedure will be exactly the same as before. All clay must be removed and the mould must be thoroughly cleaned. It must be prepared by being brushed over with the solution of soft soap, water and olive oil, until the surface is saturated. (Illus. 73.)

The mould will then have to be filled by fixing a wall around its outside edge to contain the plaster which will later be poured in to form the cast.

With the work illustrated here this wall was made in clay as before and firmly fixed all round the side of the mould. It was pressed tightly round the edge so that there was no possibility of the liquid plaster leaking out. Marks were made on the inside of the wall as before to act as a guide to the depth of the plaster poured in. It was desired to make this panel not more than ¾ to 1 inch in thickness.

The mould was then filled within the enclosing wall exactly as the clay panel was covered in making the mould, except for the fact that no colouring matter was used, of course, for the first coating.

When the depth of the plaster covering reached nearly ½ inch, a large rectangle of scrim cut beforehand, just a little larger in area than the size of the panel, was used for reinforcement.

A thin coating of liquid plaster was poured on to the surface of the back of the cast (now ½ inch thick) and the piece of scrim was spread right out over it, and gently, quickly and evenly pressed right into the wet plaster. The surplus scrim overlapping the edges was turned back and then flattened into the wet plaster also. The whole backing was flattened down with gentle stroking movements of the back of the fingers.

Further plaster was mixed and poured over this surface until the thickness of the whole cast was somewhere between ¾ and 1 inch.

The whole cast was then left to set quite hard. It was now ready for chipping out.

(Should there be any difficulty in fixing the surrounding clay wall when moulding

and casting a relief, an alternative way of making an enclosing wall should be mentioned —especially for larger works.

A more rigid wall may be made by lightly nailing together four lengths of wood— say 3 inches wide by $\frac{1}{2}$ inch thick, for a work of this size—standing, of course, with the $\frac{1}{2}$ inch thickness as base and the width as the height of the wall. It should be constructed closely round the panel when making the mould (and it can be kept and placed round the mould when making the cast). The wood should be then given a good coating of soap or clay-water so that the plaster will not stick to it. Any gaps, even slight ones, will of course, have to be stopped up with clay to ensure that the liquid plaster will not run out when this enclosure is being filled; or else some wet plaster will have to be brushed round the bottom of the wooden enclosure on the outside, where it makes contact with the board on which it is placed, in order to seal it for the same purpose.)

When the cast had set hard, the clay wall was pulled away and the whole cast, with the mould upon it, was placed upon its back on a bench. Some folded sacking was placed beneath it to act as a cushion and to save the cast from any jarring when being chipped out. The panel might otherwise be liable to crack or even break while the mould is being removed, although the sheet of scrim reinforcing the back should give strong support.

The chipping was done as described earlier. First the wooden supports were carefully removed by chipping out the hardened scrim ties. Then the mould was gradually reduced down to the first coloured coating of plaster, touching the face of the cast. Particular care should be taken not to attempt to remove the plaster in very large pieces. The mould is likely to come away from a relief with even more ease than a subject in the round—and large pieces of the mould will very likely bring away with them any parts of the cast which are undercut. (Illustration of cast 74.)

FINISHING AND COLOURING
PLASTER CASTS
chapter 13

Once the work in clay has been transformed into plaster it is safe from damage, in so far as it is now in a fairly hard, permanent material, friable only by direct breakage. But as soon as the first freshness of the white cast wears off plaster becomes a very lifeless and dead material. It loses much of the life which is given to the form by the wet clay when impregnated with water. This is largely because of the extremely dry and matt quality of a plaster surface.

Plaster will also pick up dust from the atmosphere on its outer surfaces, often leaving the recesses considerably lighter in tone, and this tends to accent the shabby appearance which an untouched plaster cast soon gains when left untreated. A cast in its natural untreated state can be cleaned by being entirely soaked for the best part of a day in a receptacle of water. The water should cover it entirely and dust marks may be gently sponged away while it is still under water.

Usually, however, it is far better to treat a new cast in some way which will give it a more permanently attractive surface, once the cast is hard and absolutely free from moisture. A new cast will usually take some weeks at least to dry out thoroughly in the atmosphere.

The process of drying out may be somewhat accelerated by placing the cast near a stove or other source of heating, but it must on no account be placed too near, as the plaster will tend to powder if it is dried by heat at too great a rate. It is better, also, to keep turning the cast round at intervals so that the heat is evenly distributed.

Plaster is usually only an intermediate stage in between the clay and the work being cast in bronze or other material. But as bronze casting is an extremely costly process these days, few sculptors can afford to have many of their works put into this permanent material.

In order therefore, to give the plaster the appearance of bronze, for which it has been designed, resort is very often had to some form of coloration and finish which can be almost undistinguishable from the bronze itself.

In spite of the fact that it would be preferable and no doubt more aesthetically honest to have the work actually cast in metal, to give such a finish to the plaster will, after all,

leave it with an appearance almost indistinguishable from the final one intended by the sculptor when he first made his model in clay. Indeed, surprisingly enough, it is sometimes more difficult to arrive at a satisfactory coloration and finish on a real bronze surface than upon a plaster one. But, of course, time—and atmosphere—will, themselves, vastly improve an actual bronze and give it their own patina and variety of hue.

In order to have an actual bronze replica of the work made, the plaster cast is sent to a bronze foundry where, if the cire-perdue (or lost-wax) method is used, a mould is first made from the cast in gelatine. This mould is then filled with wax to the thickness required for the bronze itself. Inside this thickness of wax the hollow is filled with a core of pounded brick and plaster or clay, made into a heavy paste with water, which will quickly dry into a hard mass. The outside gelatine moulds are then removed. Extremely thin metal rods are next fixed, at intervals, right through the wax into the core. They are also left protruding on the outside of the wax replica, to be embedded into further outer moulds, made of a similar substance to the inner core though applied to the outside of the wax in more liquid coatings.

When the whole is dry and the mould and the inner core are quite hard, the fine metal rods will hold the outer moulds in true position with the inner core, while the whole body is heated in a furnace. This melts out the wax leaving space for the molten metal to be run in.

When the metal, which now replaces the wax, has cooled, the outer moulds are broken off. The bronze—which is an alloy of copper and tin, sometimes with the addition of some lead or zinc—may then be seen in its natural colour, which usually verges from a hot yellow to a golden brown.

This colour is one which, in its natural state, seldom suits the sculpture—it has a raw quality which will be modified enormously by the atmosphere itself in the course of time, in any case. But the colour is usually altered or modified before leaving the foundry, or else it will be done by the sculptor himself when he receives his work back in bronze. Most of these modifications or alterations of colour are anticipations of the coloration and patination, which time and atmosphere will themselves give. They are usually achieved by the applications of chemicals in solution (or in the form of gas) to the surface of the new bronze, either cold or when the bronze is heated.

There is always a certain chanciness in patinating bronzes, owing to the varying nature of the alloy and other factors, and a bronze has often to be re-coloured with considerable patience before a really beautiful and suitable colour and finish can be obtained. Repeated hand polishing with the use of a little wax and sometimes French chalk, can play no inconsiderable part in bringing out the beautiful surface qualities of bronze.

Nearly every sculptor has his own recipe for colouring plaster, in order to give to it much the effect of actual bronze—the effective recipes are usually based upon a real appreciation of the beautiful qualities of actual bronzes.

Some of these methods are based upon the dry coloration which chemically treated bronze can give, when the action of the chemical first raises a light corrosion or verdigris —for that is what really happens when sal-ammoniac or dilute nitric acid, or any other chemicals, are applied to the surface of the metal. This is the source of the beautiful greens, blues and other colourings which give decorative mystery to bronzes after they have been submitted to long patination, by exposure to the atmosphere or burial in the earth. These chemical colorations are a substitute for the variety of hue produced by nature on the earlier handwork of man.

In order to give something of these effects to the plaster cast there are innumerable recipes extant. A coat, or coatings of powder-colour mixed with milk or casein, followed by some slight polishing with cotton wool which has been dabbed into some talc (French chalk) is one method.

Painting the cast first with a fairly opaque coat of poster colour and then with a more transparent coat of lighter colour, is another.

The method described here is one which has been used repeatedly by the author. Properly applied, it will give to the cast an appearance practically indistinguishable from bronze; except, of course, that over the years the extremely fine, silky texture of actual bronze will give a polish not entirely to be simulated by any other material whatsoever.

The extremely matt effects which are often first obtained by chemicals on new bronzes, usually soon wear off and give place to a darker and more shiny appearance. Even when they are first obtained on actual bronze, surprisingly, they can make it look more like distempered plaster than bronze. These effects simulated on plaster can often have a somewhat cheap appearance and they are not recommended.

Here is the method recommended. Give the plaster cast—which we will suppose to be a head in the first instance, and which must, of course, be bone dry—a coat of White Polish (which is one of the thinnest forms of shellac varnish—it can be diluted with methylated spirits if it has thickened). When this has dried thoroughly, pour some of the polish into a saucer and mix into it some burnt umber—this is a hot, brown powder-colour—and give the cast a not too thick but free coating of this mixture. Work quickly and do not attempt to make the colour run too evenly—a slightly transparent, but none the less a deep, strongly coloured tone is useful here.

Do not keep returning to make the colour look even, or the cast will become too heavily varnished and shiny. Even if this should happen, the polish can soon be reduced

or removed by using a wad of cotton wool dipped in methylated spirits over the surface —the spirits will act as a solvent.

Now get some good gold bronze-powder of a full, rich, warm colour. Using a little of the white polish as a vehicle and dragging fresh bronze powder into it, a little at a time as it is being used with the brush, touch up all the prominences of the cast with the gold bronze. Where these touches of gold look too aggressive, glaze over the gold bronze with semi-transparent, light washes of the umber powder mixed with some thin polish. Alternatively, the bronze powder may be applied to prominences by brushing it on dry, or by rubbing it on with the finger tips, while the coat of shellac and umber is still tacky, just before it is quite dry.

If this operation has been carried out successfully, the cast will now have very much the appearance of a real bronze casting after removal from the furnace before it has been treated for colour. But it will look somewhat raw and coarse. There should be no attempt to make the colour more even, or to refine it at this stage, but it should be left to dry hard.

Then get a lump of beeswax and shred it finely into the top of a tin or other small receptacle, with a knife. Just cover this pile of wax shreds with some turpentine and leave it to soak overnight. By the next morning the wax should have dissolved, turning the mixture into a thickish and nearly transparent, somewhat jelly-like substance. The wax may be dissolved more quickly by heating it with the turpentine in a tin placed in a pan of water—but this is a dangerous operation as turpentine will very easily catch fire (even the vapour) and it is not recommended.

Into this thickish solution mix whatever colour you have in mind for the final bronze. Artists' oil colour straight from the tube will serve well here; a prussian blue with burnt sienna will give a rich green base with immense depth of tone whether it verges towards the olive or the blue side.

Modification of the colour at this stage can, of course, be made by the addition of some yellow ochre or viridian or any other colour desired; even a very little white may be added, but the whole mixture should be transparent rather than opaque.

This colour, which should be most thoroughly stirred into the wax and turpentine mixture with a palette knife, should rather act as a colouring for the wax mixture only, and should not be so solid that the wax acts merely as a vehicle for the colour.

The coloured wax mixture should now be stippled over the whole surface of the cast. If the wax is too stiff or it does not for some reason go on well, the cast can be slightly warmed all over beforehand but if the mixture has been rightly made with just sufficient turpentine, this should not be at all necessary. It is best to use a hog's hair brush for this operation and to spread the coloured wax very evenly and not too thickly, by stippling

hard over the whole surface and into all the crevices. This covering will have a quite shiny semi-transparent quality while wet, but as it dries it will be somewhat absorbed by the cast and become quite matt and rather opaque in quality.

This coating of wax should be left to dry completely or until it reaches a stage just before it is quite dry, when it will be found, by touching it, that it is so very tacky that it can be rubbed lightly with a cloth without moving it at all.

At this stage it will probably look quite like an opaque coat of paint, hiding all the umber and gold shellac beneath. It should now be slightly polished with a very soft cloth.

When it is completely dry this polishing process can be continued with the additional use of some fine French chalk, either by shaking this chalk all over the cast with a soft brush and then removing the surplus, or by continually dipping the cloth, or better still wads of cotton wool into the chalk as the polishing continues. This will give the surface a certain bloom as well as helping to polish the wax.

If the chalk shows too strongly as a white bloom, a slight stipple or even a touch with a soft hog's hair brush, damped with the very slightest touch of turpentine, will quickly spread the chalk and restore the deeper colour of the wax—and also remove the shine—and the polishing can be resumed.

As the model is further polished the broken ground of the burnt umber and bronze beneath will begin to make their presence felt, and the outside coloured wax will become more and more transparent. The effect should be that of a dark, hot and slightly glowing material beneath, masked by the slightly lighter and cooler colour above.

Moreover, the general colour can be most easily changed in this state. The very slightest scumble or glaze of colour put on with an almost dry brush will immediately register on the waxed surface and further soft polishing with a little French chalk will incorporate it into the general tonality.

If the turpentine is too stringent in removing the surplus chalk, a brush, very slightly damped with water, will do the same job.

As the umber and gold undercoating is sealed in shellac varnish (with methylated spirits as a solvent) the wax colour (with turpentine as a solvent) will in no way interfere with this surface or pull it up when rubbed.

As with all such processes some art and taste and some love for a fine surface will be the requisites for a successful work, but the most subtle and varied tonalities, colours and surfaces can be obtained by this method. The process should not be hurried and the final colouring may be arrived at after working over the surface with the thinnest of glazings or scumblings over some days or weeks.

A variation of this method often used is to rub or pounce powder colour on to the wax surface to alter and vary its hue. Once again, the use of a very little chalk used over

the powder will help to incorporate it into the general colour.

If beeswax is not available almost any wax in paste form—not liquid—will serve, though a little less well; wax floor-polish, even brown or black boot polish with a wax basis, can sometimes be very usefully employed.

Terracotta or baked clay in some form has also been used almost from time immemorial, as a final material for sculpture. The requisite for terracotta is that the clay model shall be hollow and of even thickness throughout, without the admixture of any foreign matter in its composition. It can then shrink evenly all over as it dries, when it can be baked hard in an oven, or even by the sun, into a more or less permanent material.

To attain this end the clay model must be cut into sections, each of which must be hollowed out to even thickness, before being joined up again, with the application of a creamy solution of clay and water known as "slip". Alternatively the clay must be pressed to even thickness into piece moulds of plaster (this method is known as "squeezing"), and the separate sections of the model so obtained must also be joined together in the same way.

Any armature around which the clay model has been built in the first method has, of course, to be removed when the model is first cut into sections for hollowing out.

Terracotta may be of almost any colour ranging from white, through the buffs, yellows, pinks and reds almost to black. But the colour of sculpture mostly associated with typical terracotta, verges from a biscuit-buff, through the yellows and pinks to a warm brown. Often, after firing, a cool bloom is left on the surface which greatly enhances the evocative, elemental quality of the material and gives an atmospheric quality to the colour.

The characteristic of terracotta in its untreated state is its very dry porous texture. Its surface can be somewhat enlivened by polishing; the application of a little wax, or even washes of oil paint diluted with turpentine, polished here and there with the addition of French chalk, sometimes helps to give it a more attractive finish.

By the same methods a plaster cast can be given a somewhat similar finish. But the close and rather uneven density of plaster is apt to make the cast take any wash of colour such as venetian, light or indian red—which are often used to simulate the appearance of terracotta—rather unevenly.

It is perhaps better to give the cast a thin coat of white polish first, in order to stop the absorption, and when this is absolutely dry, to work over this surface with "poster" colours or any other thin distemper colours. Start by applying the main colour desired, opaquely, and then work over the top of this colour with very thin washes, glazes or scumbles of lighter colour, finally using just a little French chalk and a wad of cotton wool to give the very slightest polish to prominences.

Alternatively, a little powder colour mixed with some glue size to hold it together and a little gilders' whiting (or a touch of Titanium white)—making a sort of very thin coloured gesso—can sometimes obtain excellent dry effects used in a similar way.

Even if the specific imitation of the appearance of other materials is not desired, it will still be an improvement to attempt to give some sense of quality to the dead white surface of plaster of Paris, if the character of the original clay sculpture is to be preserved, not to say brought to life again.

The qualities required, at the least, are some translucency to relieve the utterly dead opacity of the white cast and some little variation of hue; more especially as soon as the cast has lost its original white purity by picking up grime from the atmosphere.

To apply a coat or coatings, of white polish alone, is the simplest method of giving a slightly ivory and polished appearance to the cast. A little raw umber, yellow ochre or other colour may be added to the polish to give variety and warmth. If it looks too strong in hue or the polish becomes too shiny, a wad of cotton wool dipped in methylated spirits may be used to dissolve and move the polish on the top surfaces, leaving the recesses a little deeper in colour and tone. More deeply coloured shellac varnishes themselves, up to orange, may be obtained to work with or upon, instead of the white polish, if preferred.

A thin top coating of the beeswax dissolved in turpentine may be applied over the dry shellac and then given a slight polish with some dressing of French chalk. This may be found to be a rather more sympathetic finish than the shellac alone and its colour may be somewhat altered or varied by the application of powdered colour which will adhere to the wax to some extent, soon after the wax has been applied. But the somewhat mechanical shine of the shellac, when first applied alone, will become greatly modified with the passage of time in any case.

Alternatively, the cast may be well waxed without the coat of shellac first, and if the top surfaces are a little polished when the wax is dry it will greatly improve the appearance of the cast. To warm the cast evenly all over, in front of a fire (but not too near), is useful beforehand, here. If the wax and turpentine can be safely heated also, in a tin placed within a pan of water, this will greatly help the mixture to saturate properly into the surface of the plaster—but again, too strong a warning cannot be given as to the danger of letting the wax and turpentine catch alight or splash out. The turpentine must on no account be allowed to come to the boil, but should be heated only sufficiently to allow it to impregnate the melted wax thoroughly and to dilute it; it is best to remove it from the source of heat as soon as the mixture becomes quite transparent.

Yet another method of giving some translucency to plaster and of protecting it from absorbing dust is to give it some coatings of ordinary commercial boiled linseed

oil; this will turn it slightly yellow but also it will darken very considerably with time, and except for the virtue of simplicity this method has perhaps less to recommend it than either the use of wax or shellac.

If a visit is paid to the sculpture section of any great museum on a well-lit day—for instance the Victoria and Albert Museum in London where, on the lower floor there is, well displayed, against a near-white background, a large and impressive permanent exhibition of fifteenth and sixteenth century works in every material—the range and variety of tint and texture in the sculpture all around can hardly fail to act as an inspiration in suggesting finish and coloration, even as it applies to the more pedestrian material with which we are dealing.

Subtle greys alternate with the translucent ivories, yellows, pinks and browns on the marbles, patinated as they have been by the hand of man and by the conditioning of time and the elements. Terracottas, varying in shade from biscuit-yellow to deep golden brown, often have traces of gilding and of painted colour on their surfaces, which now have left on them only a glow or bloom of suggestive beauty, to unify the sculptural forms which they decorate.

To attempt to copy exactly the colour and patterning of marble or stone on a plaster surface is likely to be doomed to failure, but for those who are receptive to colour, texture and surface-finish and its congruity to the form with which it is united, the sensations aroused by contemplation of such a collection of sculpture and such rare materials should be of the greatest possible suggestive value.

As in all things technical described in this book, to give the general principles of a mode of procedure has always been the aim, in order to form a basis from which a student may develop his own methods suited to his own ends.

Plaster may be stained or painted, stippled or glazed; it may be left near its natural colour or darkened to give the glow of bronze, or the sheen and colour of ebony; it may be left matt or it may be polished. If you happen to have a great love for smooth surfaces you may work all over the cast with steel tools and glass-paper, until it has nearly the fine surface of marble itself; if you have built your model so that its final form and texture expresses to perfection the development of your plastic idea, you may leave it exactly as it is cast. Your colouring and finishing of the surface of the cast should always be directed towards the realization of the sculptural idea as a unified end.

No recipe will be of service unless used with art and sensibility; any method whatsoever will be justified if it looks entirely apt to the work. Any of the methods suggested may be used separately or in conjunction with each other.

Only one warning should perhaps be given: use no colouring, whether polish, varnish or paint, of such a thick consistency that it will blunt or clog up the form you have made.

Even if your new plaster cast is to be used for the making of an actual bronze in the foundry however, it will be well shellacked by the founder before he takes the gelatine mould from it to make the wax. If the cast has been bronzed or shellacked already, he will probably make the moulds directly upon it without any further shellacking, so that you need not be too nervous, either, when colouring it; provided, as in all things done here, reasonable forethought and care are used.

There is one other prime method of giving plaster a more sympathetic colouring than it has in its natural state and perhaps this should be mentioned here. It is, to add powder colour when the plaster is being mixed to form the cast. This method has one difficulty but it can be rather an important one, especially when making a first cast by waste-moulding the model; any working over the surface of a cast coloured by this method will be likely to show a rather different quality and tonality of colour beneath the surface of the part retouched. It will be extremely difficult also, when adding any further plaster to make it exactly the same colour. None the less, some interesting and attractive effects can be made by this method.

If it should be attempted, a bowl large enough to contain sufficient plaster of the one colour to cover the whole surface of the mould should be used if possible. This covering operation should be carried out with the one mixing. In any case enough water should be tinted with the powder colour to serve for any near surface work, and when the colour is quite thoroughly mixed with the water enough should be poured off into another vessel to be used for any second or further mixing of the plaster which may be necessary. This method of colouring plaster is perhaps best employed for small works which will require little retouching of the surface.

It will be safer to mix the powder colour into the water by first making a very smooth paste of the colour with the addition of a small amount of water, separately. Use a palette knife to grind out any hard particles or lumps completely, as these would show in the cast as separate specks. This colour paste can then be added, slowly, to the water in which the plaster is going to be mixed, stirring the water until it is evenly diluted throughout.

BOOKS SUGGESTED FOR STUDY OF ANATOMY

ANATOMY FOR ARTISTS
by Eugenie Wolff, M.B.(Lond.), F.R.C.S.(Eng.)
H. K. Lewis & Co. Ltd., London.

ANATOMICAL DIAGRAMS
by James M. Dunlop, A.R.C.A.
G. Bell & Sons Ltd., London.

HUMAN ANATOMY FOR ART STUDENTS
by Sir Alfred D. Fripp and Ralph Thompson.
Seeley & Co. Ltd., London.

THE HUMAN MACHINE
by George B. Bridgman.
John Lane, The Bodley Head, London.

ANATOMY FOR ARTISTS
by 'Vesalius'
(first published 1553)

INDEX